IMAGES
of America

MONTEREY
PENINSULA
THE GOLDEN AGE

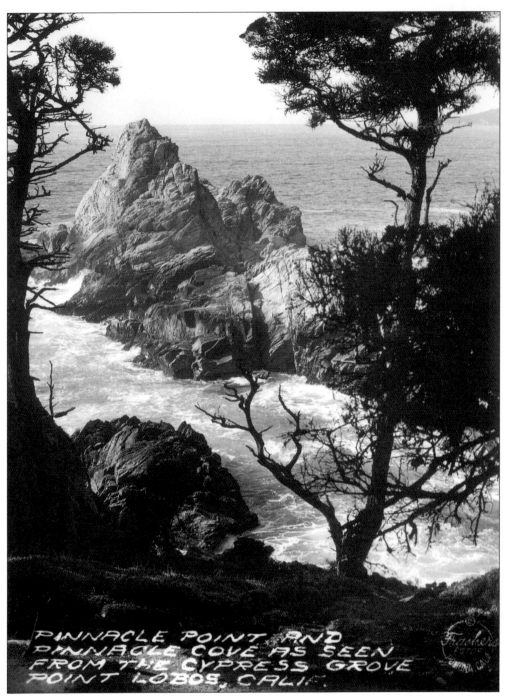

PINNACLE POINT AND PINNACLE COVE AS SEEN FROM THE CYPRESS GROVE POINT LOBOS, CALIF.

Before it became a state reserve, Point Lobos served many purposes. In the1850s it was the site of a Chinese fishing village and a granite quarry. In the 1860s it was a Portuguese whaling village. In the 1870s it was the site of a coal company. In the 1940s it was the site of a secret army and air force operation with anti-aircraft capabilities. Despite these potentially disastrous uses, in 1960, 750 underwater acres were added to the reserve, now one of the largest marine sanctuaries.

IMAGES
of America

MONTEREY
PENINSULA
THE GOLDEN AGE

Kim Coventry

To my good friends Suzanne and Denis Rynen with thanks for including me in so many wonderful occasions.

With much love,

Kim Coventry

ARCADIA

Published by Arcadia Publishing,
an imprint of Tempus Publishing, Inc.
3047 N. Lincoln Ave., Suite 410
Chicago, IL 60657

Printed in Great Britain.

Library of Congress Catalog Card Number: 2002110138

For all general information contact Arcadia Publishing at:
Telephone 843-853-2070
Fax 843-853-0044
E-Mail sales@arcadiapublishing.com

For customer service and orders:
Toll-Free 1-888-313-2665

Visit us on the internet at http://www.arcadiapublishing.com

(*cover photo*) Picnickers at Pebble Beach in *c.* 1902. Courtesy of Monterey Public Library.

CONTENTS

I have often asked myself why I collect images of the Monterey Peninsula as well as what I might do with them. The answer came several years ago when I began to recall my youth exploring the peninsula with my stepfather, James Alfred Coventry. He was a man with untold patience and a keen sense of a child's inherent curiosity. Together with him and my brothers Robert and David, we spent countless afternoons visiting local spots—Fisherman's Wharf, Dennis the Menace Park, the cemetery in Monterey, Big Sur, Farm Center, the mission at Carmel, the Naval Post Graduate School, Lake El Estero, and Cannery Row. He provided the entertainment, and we grew to know the peninsula. These memories are my motivation and my inspiration. This book is lovingly dedicated to his memory.

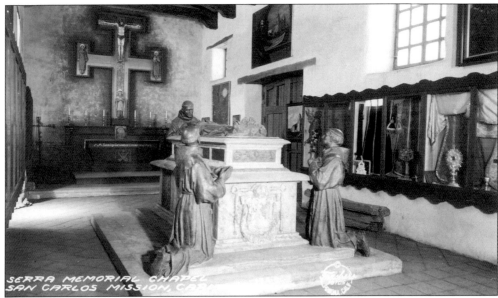

This bronze and stone sarcophagus of Father Junípero Serra at Carmel mission depicts Serra on his deathbed surrounded by his colleagues Fathers Crespi (who preceded him in death) at his head, and Padres Lopez and Lasuen (who succeeded him as head of California's missions) at his feet. The sarcophagus is the work of local sculptor Joseph Jacinto Mora (1876–1947), who set up a studio on the grounds of the mission while working on the piece.

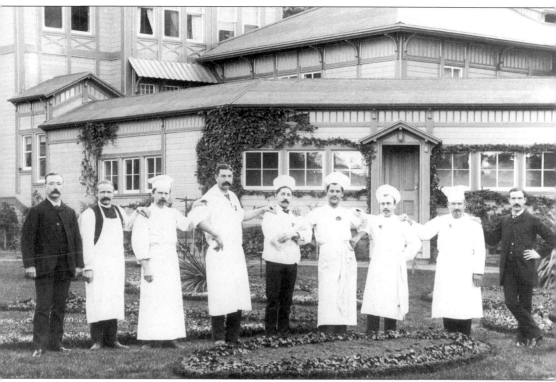

Posing in front of the Stick Style Hotel Del Monte, *c.* 1890, is the cooking staff. At the time, the famed dining room could seat some 500 people. Photo by C.W.J. Johnson, courtesy of the Monterey Public Library.

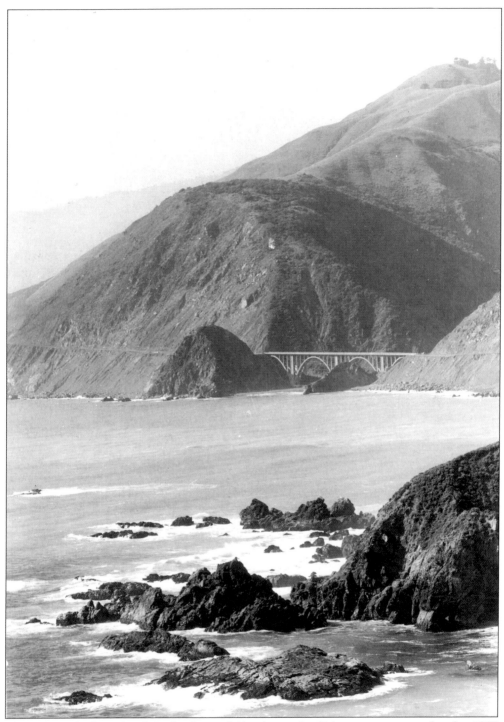

The multi-arched Big Creek Bridge, located 40 miles south of Monterey, was completed in 1937 on the Pacific Coast Highway. It was the last of the many bridges built in the 1930s between Carmel and Lucia, making it possible to travel between San Francisco and Los Angeles on the coast rather than taking the longer and often treacherous Old Coast Road into the mountains.

8

INTRODUCTION

The role of the Monterey Peninsula in early western U.S. history is so pivotal that in his book *Storied Land: Community and Memory in Monterey* (2001), sociologist John Walton compares the peninsula's importance in the west to the importance of the Massachusetts Bay Colony to the settlement in the east. It is ironic, then, that there is such a dearth of written history (popular or scholarly) about the peninsula. To be sure, some of the area's history is tangibly evident in the carefully restored Colonial revival buildings of Monterey, the street names honoring Spanish and Mexican explorers and original land grant holders, and the monuments erected to their memory. But more has been lost or neglected than has been recorded.

Throughout its history, the Monterey Peninsula has been the subject of novels, poetry, movies, photography, painting, and theater. Still, precious few full-length scholarly historical narratives exist. One notable exception is the work of the Work Projects Administration, which published a guide to the peninsula in the mid-1940s. Recently, however, several histories have appeared on specific subjects such as the Cypress Point Club, Pebble Beach golf links, the fishing industry, and the Chinese and Italian immigrant populations.

While there is no visual record of the early period to which Walton refers, there are photographs of the peninsula starting in the late 1880s (thanks mainly to the many skilled professional photographers who made the peninsula their home), which document the area— its architecture, residents, cultural events, and landscape.

This book focuses on the photography of the period from 1880 to 1940, during which railroad service was extended and brought visitors to the peninsula from San Francisco and beyond. During this period, the peninsula grew from a vacation spot with one luxury hotel to a vibrant community in the fast-paced 1920s and 1930s, when the Pacific Coast Highway made the area a destination on the drive from San Francisco to Los Angeles. It is also the period during which the fishing industry, specifically sardine canning and reduction plants, temporarily changed the economy of this otherwise service-based community.

It is hoped that this book will bring these images to light and to bear on future historical work. Someone once remarked to me that the gods had surely had a hand in the creation of many lands, but that it is here, on the Monterey Peninsula, that they did their best work. The photographs are the evidence of that and of the changes that took place during the peninsula's golden era.

Kim Coventry
Chicago
July 15, 2002

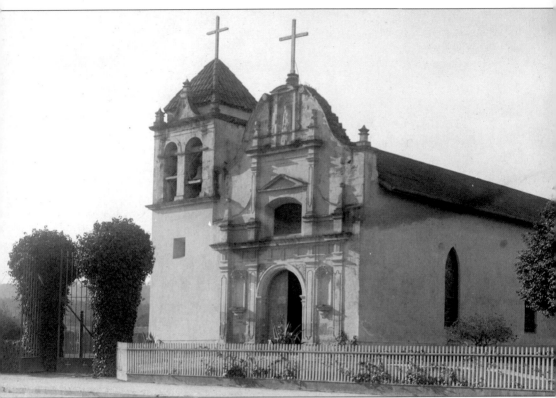

In June 1770, 168 years after Spanish explorer Sebastián Vizcaíno first landed at Monterey Bay, Father Junípero Serra dedicated Mission San Carlos Borroméo de Monterey (later the Royal Presidio Chapel or Capilla Royal and now San Carlos Cathedral). Within a year, in search of more fertile ground, as well as to escape government interference in church business, Serra moved the seat of his church over the hill to an area near the mouth of the Carmel River, but the Royal Presidio Chapel continued to serve as a place of worship. Pictured here is the fourth structure built at this site. It was finished in 1797 under the direction of Father Fermin de Lasuen. In 1858 it underwent extensive restoration, and in 1865 the nave was enlarged. The exterior is made of plastered Carmel stone, and the façade (originally polychromed), with its arched doorway, Mission Order Gable, bell tower, and ornamental tracery, is among the most ornate of the early California missions.

One

MONTEREY

Richard Henry Dana, who recorded his impression of his 1836 visit to Monterey in his book *Two Years Before the Mast*, describes the scene. "The Bay of Monterey is wide at the entrance, being about 24 miles between the two points, Ano Nuevo at the north, and Pinos at the south, but narrows gradually as you approach the town, which is situated in a bend, or large cove, at the south-eastern extremity, and from the points about 18 miles, which is the whole depth of the bay. . . . Its houses [are] of whitewashed adobe. . . . There are in this place, and in every other town which I saw in California, no streets nor fences (except that here and there a small patch might be fenced in for a garden), so that the houses are placed at random upon the green."

Incorporated in 1889

1880 Population 1,396

1890 Population 1,662

1900 Population 1,748

1910 Population 4,923

1920 Population 5,479

1930 Population 9,141

1940 Population 8,531

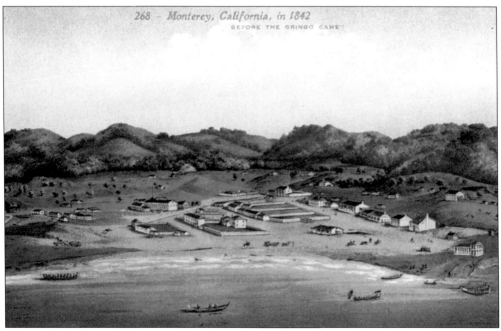

This artist's interpretation of the city of Monterey in 1842 shows the important government and residential buildings, many of which are still extant today.

SIERRA
MONUMENT
MONTEREY, CALIF.

Father Junípero Serra was memorialized in this marble sculpture donated by Jane L. Stanford, wife of the former governor and U.S. Senator Leland Stanford. It was erected in the 1890s overlooking the bay near the hilltop location of the early Spanish El Castillo fort.

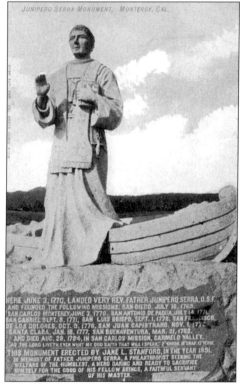

JUNIPERO SERRA MONUMENT, MONTEREY, CAL.

HERE JUNE 3, 1770, LANDED VERY REV. FATHER JUNIPERO SERRA, O.S.F. AND FOUNDED THE FOLLOWING MISSIONS: SAN DIEGO, JULY 16, 1769, SAN CARLOS MONTEREY, JUNE 3, 1770, SAN ANTONIO DE PADUA, JULY 14, 1771, SAN GABRIEL SEPT. 8, 1771, SAN LUIS OBISPO, SEPT. 1, 1772, SAN FRANCISCO, DE LOS DOLORES, OCT. 9, 1776, SAN JUAN CAPISTRANO, NOV. 1, 1776, SANTA CLARA, JAN. 18, 1777, SAN BUENAVENTURA, MAR. 21, 1782, AND DIED AUG. 28, 1784, IN SAN CARLOS MISSION, CARMELO VALLEY. AS THE LORD LIVETH, EVEN WHAT MY GOD SAITH THAT WILL I SPEAK. 2 CHRON. 18 CHAP. 13 VERSE.

THIS MONUMENT ERECTED BY JANE L. STANFORD, IN THE YEAR 1891. IN MEMORY OF FATHER JUNIPERO SERRA, A PHILANTHROPIST SEEKING THE WELFARE OF THE HUMBLEST, A HERO DARING AND READY TO SACRIFICE HIMSELF FOR THE GOOD OF HIS FELLOW BEINGS, A FAITHFUL SERVANT OF HIS MASTER.

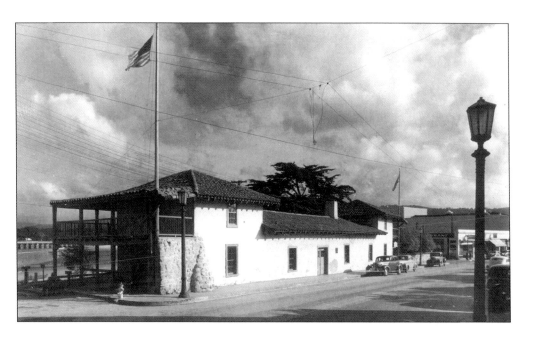

The Custom House dates to 1827. As the chief port of entry under Mexican rule from 1822 to 1846, Monterey was an essential part of Alta California's economy. Richard Henry Dana wrote about the importance of trade in Monterey in 1836 in *Two Years Before the Mast*. "Our cargo was an assorted one; that is, it consisted of everything under the sun. We had . . . everything that can be imagined, from Chinese fireworks to English cartwheels. . . . Another thing that surprised me was the quantity of silver in circulation. I never, in my life, saw so much silver at one time, as during the week we were at Monterey. The truth is, they have no credit system, no banks, and no way of investing money but I cattle. Besides silver, they have no circulation medium but hides, which sailors call 'California bank-notes.'"

It was at this location in 1846 that Commodore John Drake Sloat claimed over 600,000 square miles of land for the U.S. The importance of this building is evidenced by the fact that it was California's first registered state historic landmark.

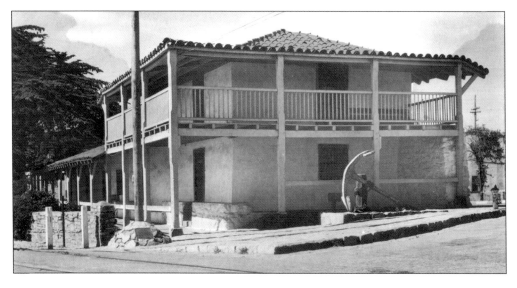

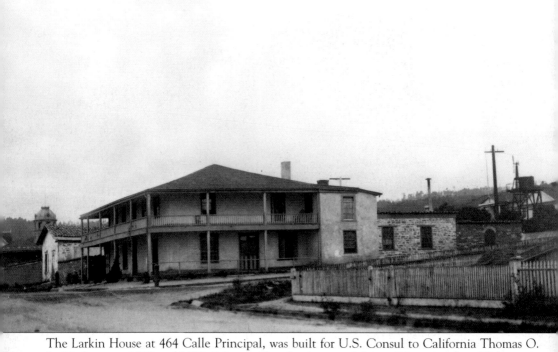

The Larkin House at 464 Calle Principal, was built for U.S. Consul to California Thomas O. Larkin between 1835 and 1837. It is considered to be one of the earliest examples of "Monterey Style" architecture. The first residence with an upper balcony, the design of the Larkin House integrated features of the California mission and eastern colonial styles, and established a new genre in California architecture. Typical features of a "Monterey Style" colonial house were a second story, continuous upper balcony with supporting posts, louvered shutters, a wood shingle roof, and double-hung windows. Its immediate influence can be seen in the Pacific House (1835), the Whaling Station (1847), and Casa Amestí (1853). Photo by Joseph K. Oliver, courtesy of Monterey Public Library.

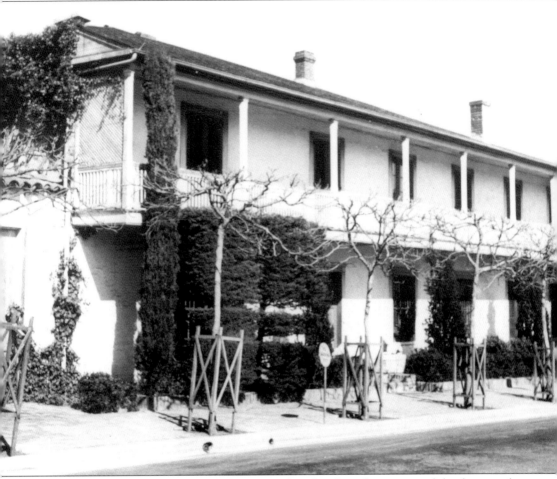

The two-story Casa Amestí, with its balconies and enclosed garden, is one of the finest and most authentically preserved examples of Spanish Colonial architecture in Monterey. Don José Amestí, a Spanish Basque, built it in about 1833. The second story was added in 1853. From 1919 to 1953 the house was owned by Frances Elkins, a famous interior designer and sister of Chicago-based estate architect David Adler, who renovated the house and designed its gardens. Sibyl Anikeyev, a photographer for the Work Projects Administration, took this photo in April 1940. Courtesy of Monterey Public Library.

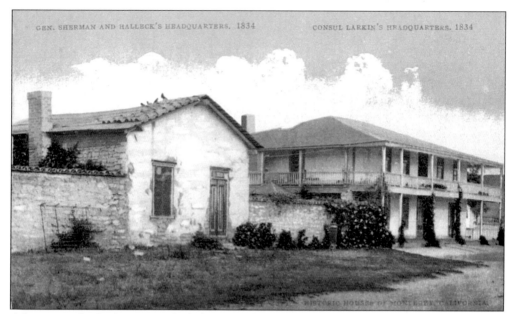

Adjacent to the Larkin House (right), is a modest Carmel stone building (left) built by Larkin in 1834, which served as headquarters for lieutenants Henry W. Halleck and William Tecumseh Sherman, who wrote about Monterey in 1849. "There are some families that style themselves Dons, do nothing but walk the streets with peaked broad-brimmed hats and cloaks or serapes, which are brightly colored, checkered panchos, a colored shirt, silk or fancy pants slashed down the outside with fringe or buttons, shoes on their feet and a cigar in their mouth."

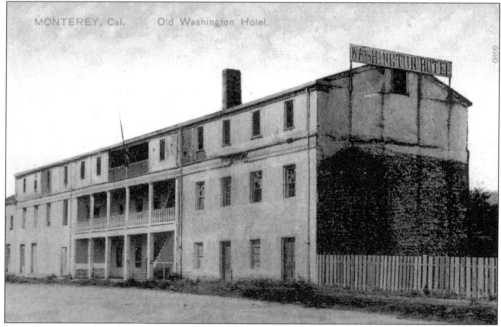

The Washington Hotel, which stood at the northwest corner of Pearl and Houston Streets, was the largest hotel in Monterey when it was completed in 1832. In 1849 it housed delegates to the Constitutional Convention. The hotel was demolished in 1914.

House of the Four Winds, or *La Casa de los Vientos*, was built by Thomas O. Larkin in 1834 had many functions, among them a store run by Governor Alvarado and the first California state hall of records.

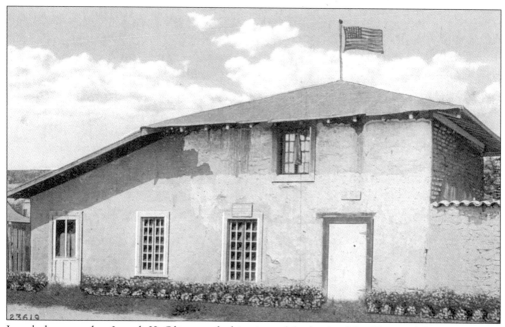

Local photographer Joseph K. Oliver took this view of the back of the House of the Four Winds in about 1890.

Stevenson House was so named after a three-month visit by the famous novelist in 1879 while he was courting the unhappily married Fanny Van de Grift Osbourne. It was built in the 1830s and was known then as the French Hotel. During his three-month stay, Robert Louis Stevenson wrote an occasional article for the *Monterey Californian*, the weekly paper. "I lodge with Dr. Heintz;" he wrote, "take my meals with [Jules] Simoneau; . . . drink daily at the Bohemia saloon; get my daily paper from Hadsell's . . . "

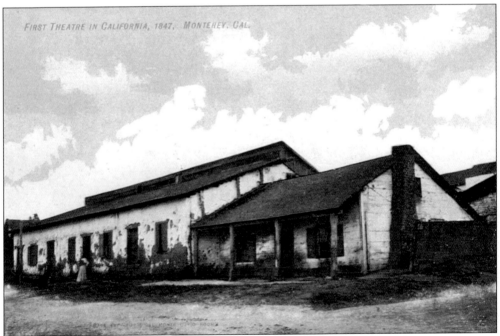

Built about 1844 by Jack Swan as a saloon and boarding house for sailors at the corner of Pacific and Scott Streets, this building became the First Theater of California just three years later when a group of Army volunteers used Swan's building as a site for their minstrel shows.

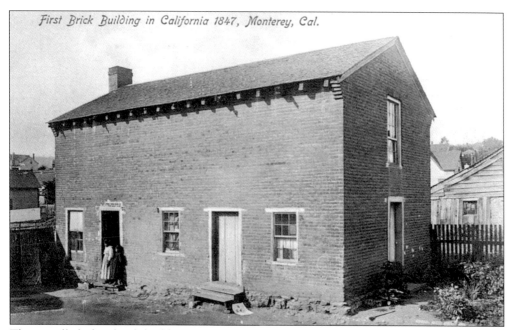

First Brick Building in California 1847, Monterey, Cal.

The so-called "first brick building" in California stands in Monterey at 351 Decatur Street. It was built in 1847 by Gallant Duncan Dickinson of Virginia who, with his family and six children, was a survivor of the ill-fated 1846 Donner party.

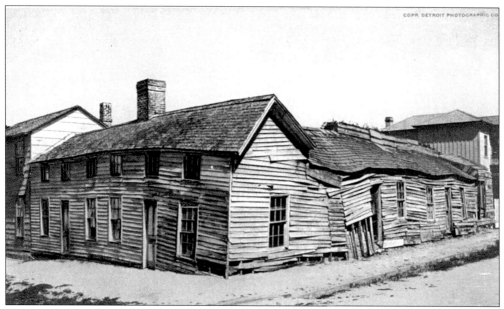

The much-reproduced first wood-framed house in California, which stood at the corner of Munras Avenue and Webster Street, was built by William Botcheson in 1847 of timber imported from Australia.

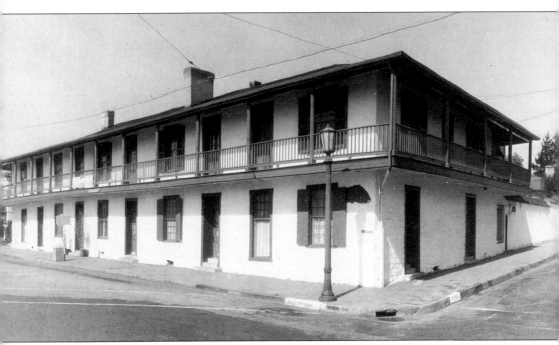

Pacific House at the corner of Calle Principal and Alvarado Streets, built as a supply depot in 1845 and enlarged in 1847 for Thomas O. Larkin, quickly became a hotel and saloon for sailors on their way to and from upper and lower California. Stylistically, the Pacific House combines the influences of Southern Spain and New England, an architectural which has been termed "Monterey," as established by the Larkin House and Casa Amestí.

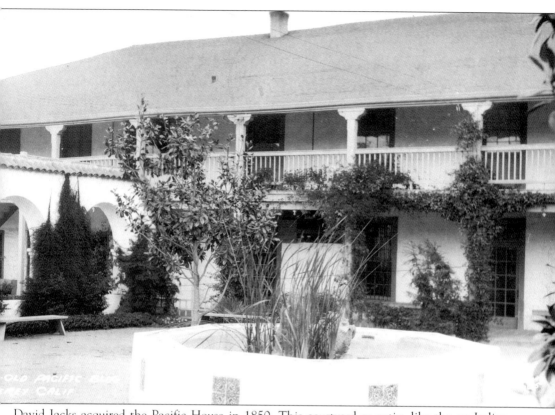

David Jacks acquired the Pacific House in 1850. This courtyard or patio, like the an Italian Cortile, derives its style from the courtyard gardens of the ancient Roman empire villas. The hexagonal pool recalls Iberian examples, as at the garden of the Alcazar, Saville, Spain.

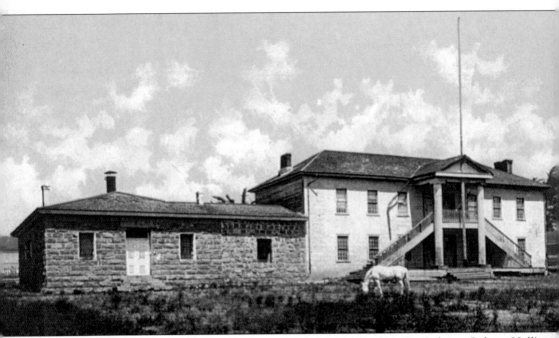

Built of locally quarried Carmel stone by the Reverend Walter D. Colton, Colton Hall's Georgian styling, hipped roof, and second-floor Classical portico and balcony (the flanking stairways were a later addition), were architecturally distinct from Monterey's Spanish Colonial Revival buildings. In 1849 the hall was the site of California's first Constitutional Convention. The one-story stone building to the left was built as the jail.

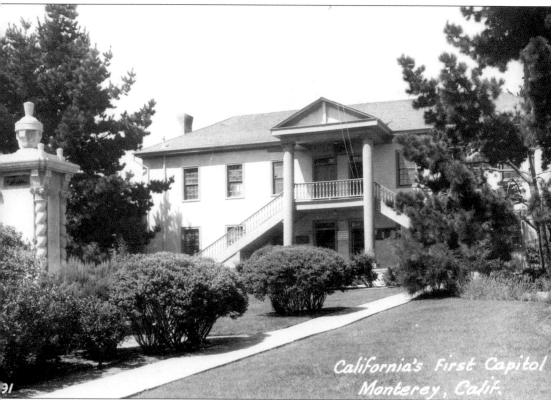

California's First Capitol
Monterey, Calif.

When Colton Hall was finally completed in 1849, Walter Colton wrote, "The lower apartments are for schools; the hall over them—70 feet by 30—is for public assemblies. The front is ornamented with a portico, which you enter from the hall. It is not an edifice that would attract any attention among public buildings in the U.S.; but in California it is without rival."

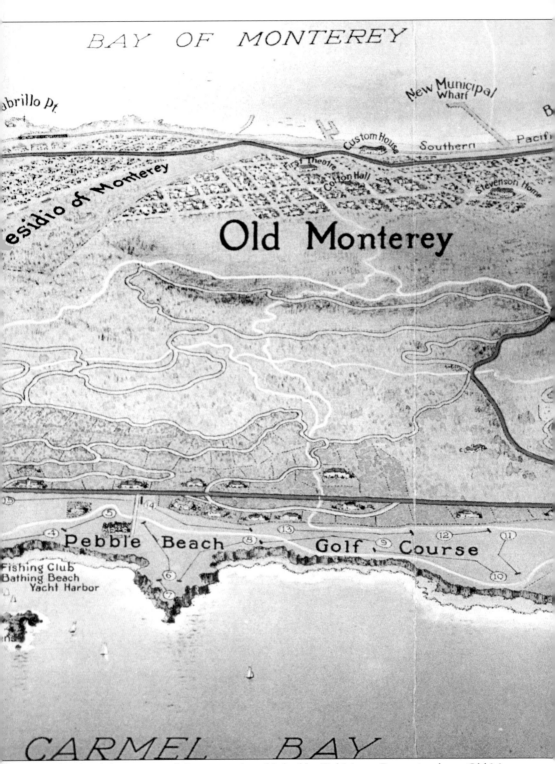

BAY OF MONTEREY

New Municipal
Wharf

abrillo Pt.

Custom House

Southern Pacifi

First Theatre

Colton Hall

Stevenson Home

esidio of Monterey

Old Monterey

Pebble Beach

Golf Course

Fishing Club
Bathing Beach
Yacht Harbor

CARMEL BAY

This detail from a map of the peninsula published by Del Monte Properties shows Old Monterey,
Hotel Del Monte and the 17-Mile Drive through Pebble Beach, c.1929. Courtesy of Monterey

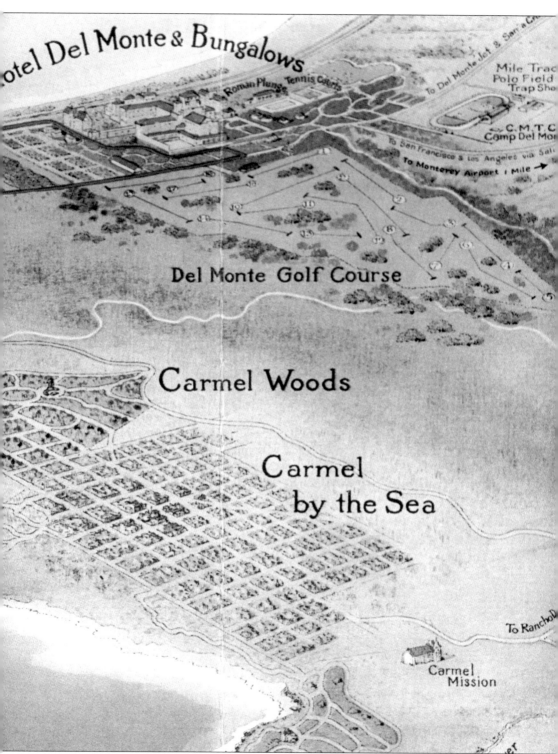

Hotel Del Monte & Bungalows

Roman Plunge Tennis Courts

To Del Monte Jct & Santa Cruz

Mile Trac
Polo Field
Trap Sho

C.M.T.C.
Camp Del Mor

To San Francisco & Los Angeles via Sali

To Monterey Airport 1 Mile →

Del Monte Golf Course

Carmel Woods

Carmel
by the Sea

To Rancho

Carmel
Mission

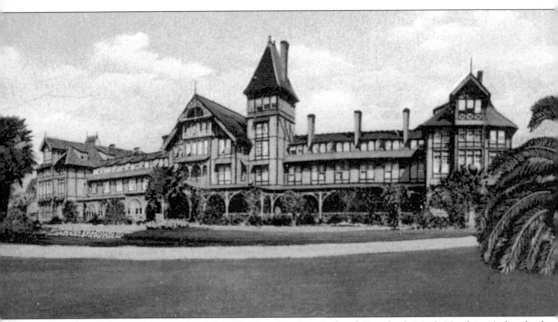

The Hotel Del Monte was built by Charles Crocker, Leland Stanford, Mark Hopkins (who died before the hotel was completed), and Collis P. Huntington, who jointly founded and operated the Pacific Improvement Company. It was "intended to bring wealth and fashion to the Pacific Coast via the new transcontinental passenger line."

Not coincidentally, the hotel was completed just as the branch line of the Southern Pacific Railroad connected Castroville to Monterey. Its lavish grounds were but 250 of the 7,000 acres (including El Pescadero and Point Pinos Ranchos, two of the largest Spanish land grants) purchased by the Pacific Improvement Company from land baron David Jacks. And though the other two surviving partners were involved, Charles Crocker was the moving force behind the creation of Hotel Del Monte.

Early in its history the hotel was the destination for wealthy families such as the Vanderbilts and Huntingtons, thousands of tourists seeking fresh air and sandy beaches, and several U.S. presidents, including Benjamin Harrison in 1891, William McKinley in 1901, and Theodore Roosevelt in 1903, who rode horseback from the hotel to Pacific Grove and Pebble Beach. Later it attracted movie stars such as Clark Gable and Gloria Swanson.

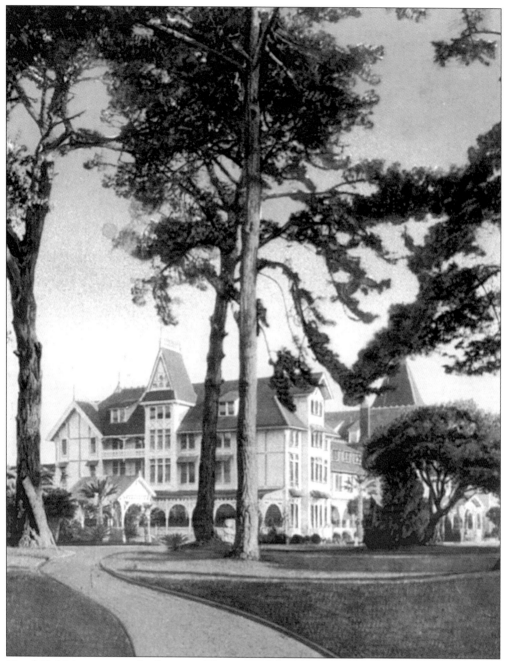

Hotel Del Monte was rebuilt twice. The original hotel, designed by Arthur Brown Jr., and completed in 1880, was a 340-foot-long Stick-Style structure with half-timber diagonal stick work, steep roofs, and an irregular silhouette. Only three hours from San Francisco by train, it could accommodate 500 guests. Soon after it opened, it was hailed as the "Queen of American Watering Places," and "the most elegant seaside establishment in the world." Built entirely from local wood, the hotel was completely consumed by fire in April 1887. In 1888, a second hotel (seen here) was constructed in much the same style as the first, though with simplified stick work. The hotel was also expanded to accommodate 750 guests.

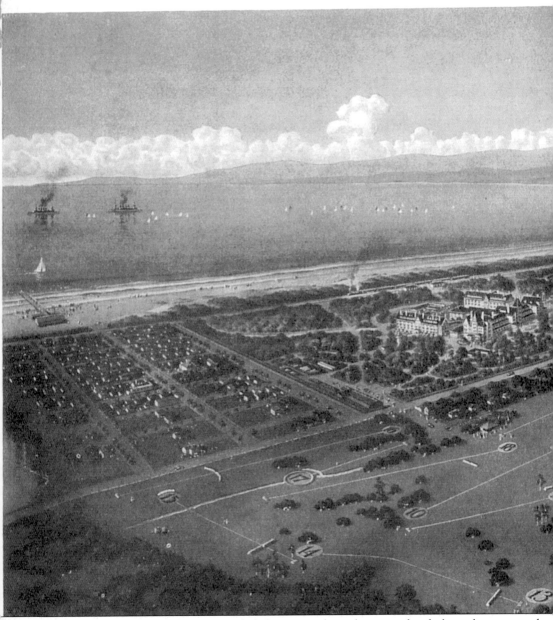

The grounds of Hotel Del Monte included a scenic drive that meandered along the coast and through naturalistic landscapes, manicured gardens, and the famous 17-Mile Drive. "[It] encircles the entire Monterey Peninsula," a brochure stated. "It passes through old Monterey with its historic memories and romantic associations of the days of the padres and the early life of the state, through

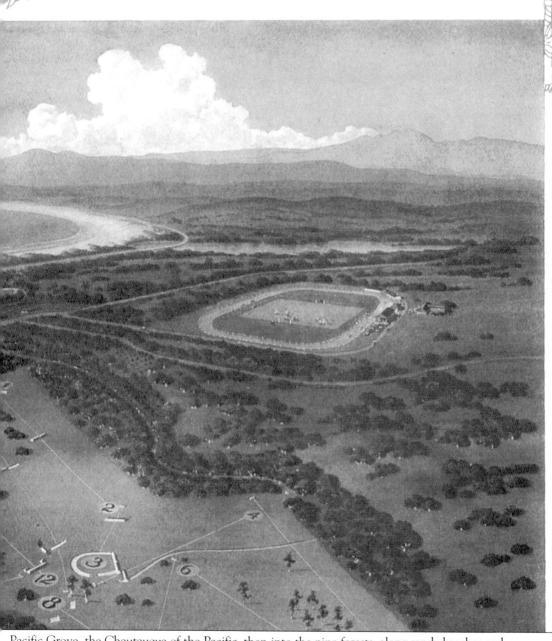

Pacific Grove, the Chautauqua of the Pacific, then into the pine forests, along sandy beaches and white sand dunes….The trip is made in automobiles from the hotel." The complex also included a famous 18-hole golf course, polo field, racetrack, and bathing pavilion. Courtesy of Henry Meade Williams Local History Department, Harrison Memorial Library, Carmel, CA.

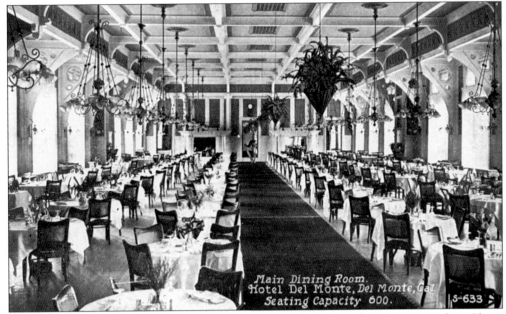

The dining room at Hotel Del Monte could seat 600 people when this photo was taken. Photo by C.W.J. Johnson, courtesy of the Monterey Public Library.

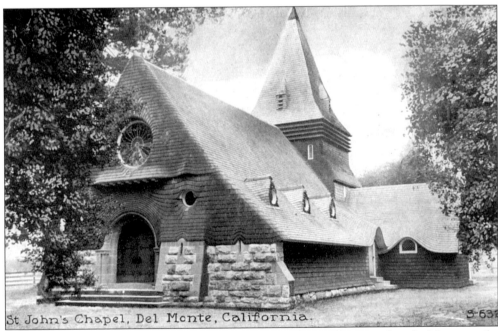

St. John's Episcopal Chapel, built on the hotel grounds in 1891, was the ideal location for weddings. Designed by British-trained architect Ernest Coxhead (1863–1933), its Shingle Style extended roofline and redwood shingle sides made it a charming destination for hotel guests. It was moved in 1958 to its present site on Mark Thomas Drive.

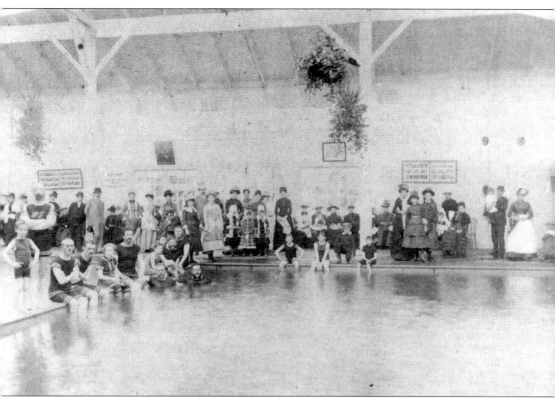

Guests of the Hotel Del Monte could use the novel beachfront bathing pavilion seen here in c. 1885. A brochure from the 1890s stated that, "The tank is lined with white tile and has a complete equipment of springboards, slides, etc. It is filled with warm salt water which is continuously changing. The hot salt baths are of great benefit to those troubled with any form of rheumatic complaint." Photo by C.W.J. Johnson, courtesy of Monterey Public Library.

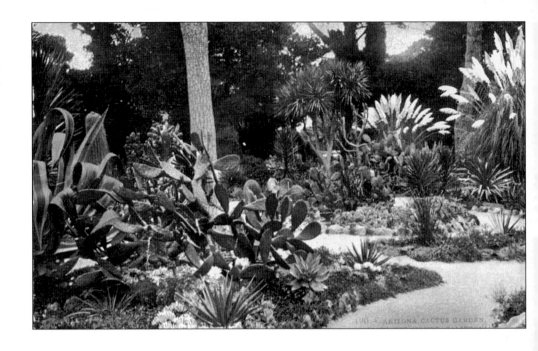

In the early 1900s the hotel grounds were described as having "one of the finest gardens of its kind in the world, containing 126 acres which have been intensely cultivated under expert care for the past 20 years." Indeed, there were 2,000 varieties of trees, plants, and shrubs, and more than 90 varieties of roses. The famed landscaping included the Arizona cactus garden (*above*) and maze garden (*below*).

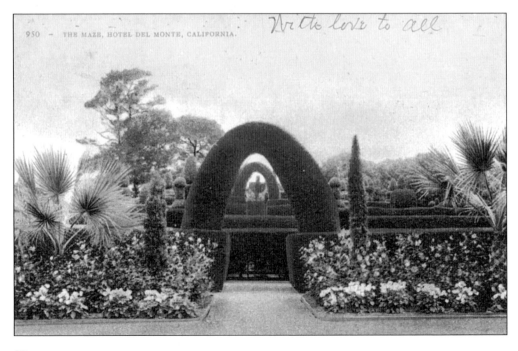

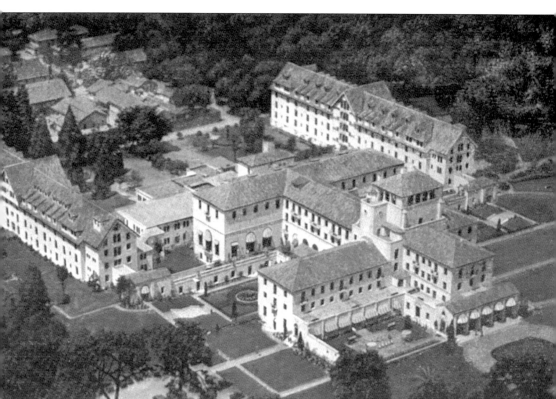

In 1924, the center section of the hotel was destroyed for a second time when a fire broke out in the cupola, leaving the center building in ashes. By 1926, the center section, designed by Lewis Hobart and Clarence Tantau, was rebuilt and substantially enlarged. But while the basic layout was preserved, the architectural style of the hotel changed dramatically. The new hotel was part of the wave of Spanish Colonial Revival architecture that California experienced in the 1920s. To integrate the two surviving Stick Style wings, the architects plastered the exterior walls and tiled the roof.

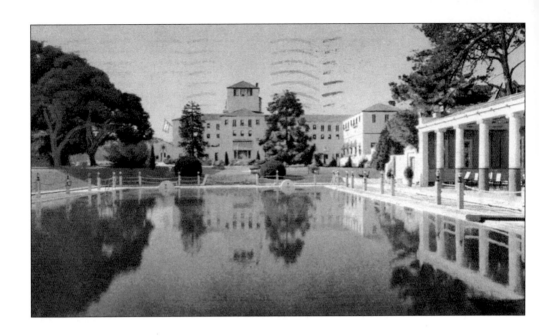

The Roman Plunge pool at Hotel Del Monte, completed in 1914, had the sort of European elegance that made the hotel famous. The vista from the pool to the lake beyond is reminiscent of the grand Italianate gardens of Tuscany.

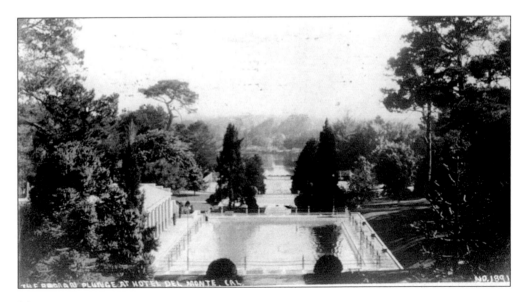

THE ROMAN PLUNGE AT HOTEL DEL MONTE CAL. NO.189.

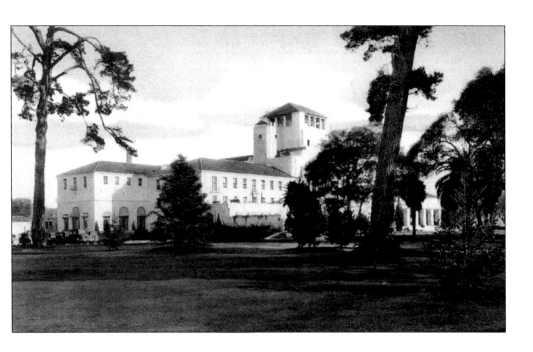

In 1943, under financial pressure and with World War II in full swing, Hotel Del Monte (now owned by Del Monte Properties Company and operated by Samuel F.B. Morse), was leased to the U.S. Navy for a preflight training school. Much of the hotel staff stayed on to tend to the needs of the cadets. After the war, the hotel served as a rehabilitation center for wounded veterans. Today it is home to the Naval Post Graduate School. In 1950, the polo field and barns were demolished and the building materials were reused for construction of the Monterey fairgrounds.

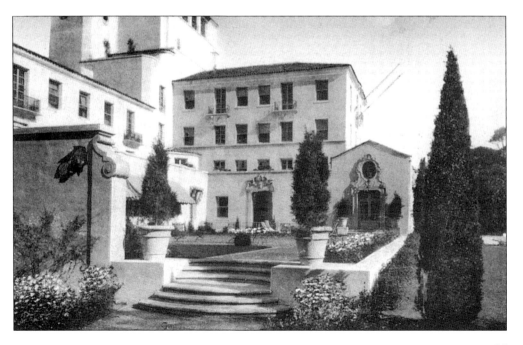

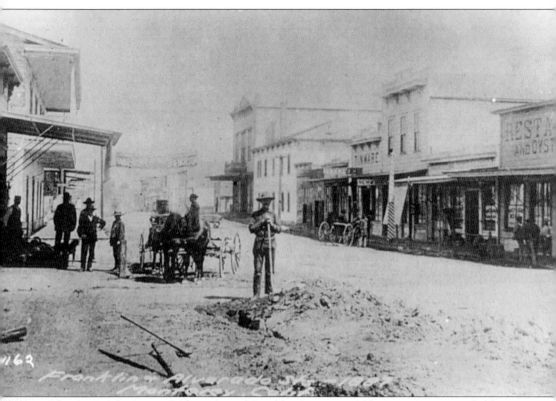

The date of this view of Alvarado and Franklin Streets in Old Monterey is recorded because it was taken as the sewer lines were being installed in 1887. On the far right is a building with a sign reading "Restaurant and Oyster Depot."

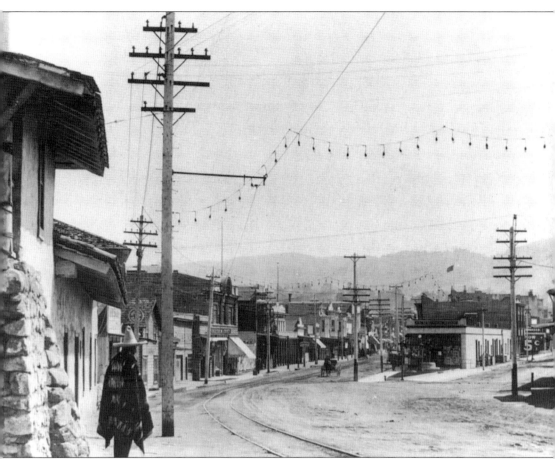

By 1890, when this photograph was taken of the corner of Alvarado Street and Calle Prinicpal, Alvarado had a carriage track down the center. Alvarado Street is named after Juan Bautista Alvarado, governor of California from 1836 to 1842. Courtesy of Monterey Public Library.

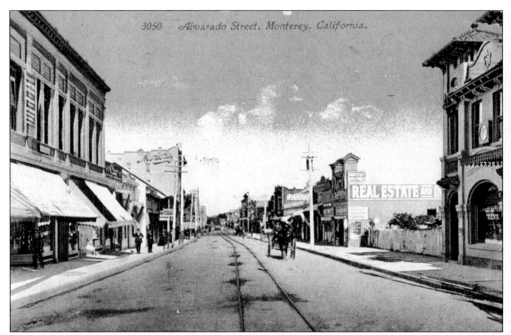

Between 1903 and 1910, William Henry Weeks designed more than a dozen buildings on Alvarado Street alone, including the Monterey Hotel (1903), the Oliver Block (1903), Monterey Mercantile (1905), and the First National Bank of Monterey (1904) seen here at the far right. The bank's scalloped gable, symmetrical tiled towers, and arched entrance are hallmarks of Mission Revival architecture. In 1915, Weeks, who practiced in a wide range of styles, designed Monterey's high school and Second Presbyterian Church.

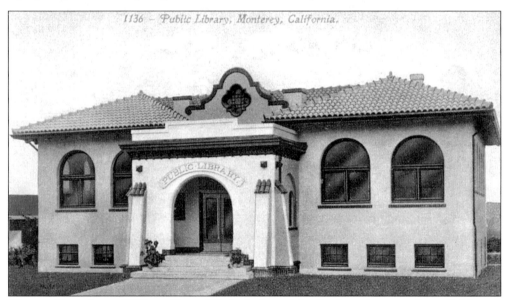

Wastonville architect William Henry Weeks built prolifically throughout northern California, including a series of public libraries funded by Andrew Carnegie. Weeks' library for the city of Monterey opened in 1911. Its eclectic Mission Style with buttresses on either side of the entrance point to Weeks' broad architectural vocabulary. It served as a library until 1952.

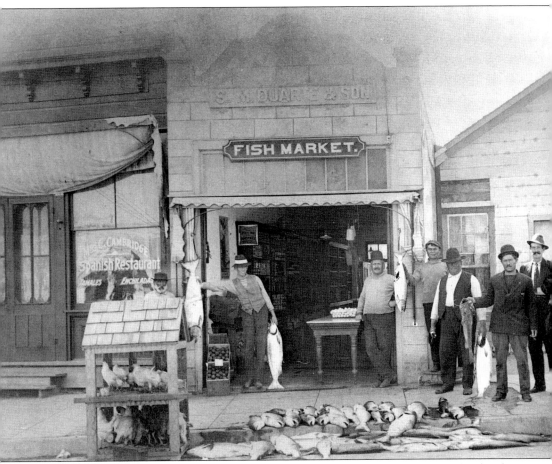

Duarte & Sons Fish Market on lower Alvarado between Decatur and Scott Streets sold to local clientele. Rosario Duarte, born in 1826, immigrated to Monterey and married Altegrasia de la Torre. The family also ran a local boat rental enterprise. Photo courtesy of Monterey Public Library.

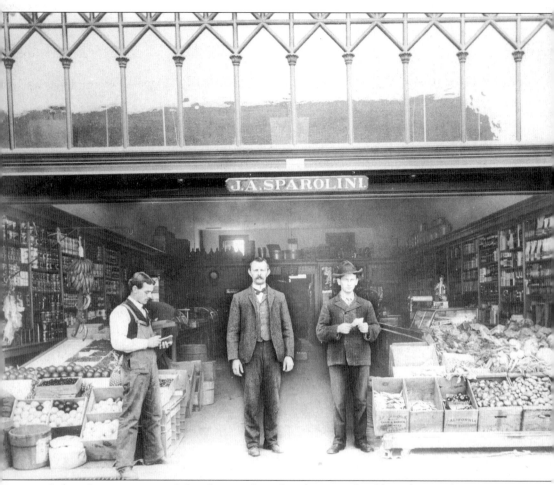

Italian-Swiss immigrant John Antone Sparolini (at center) sold produce and groceries at 417 Alvarado Street (later the site of Ortin's grocery store). C.W.J. Johnson took this photo in c.1902. Courtesy of Monterey Public Library.

Local independent merchants purchased goods delivered in bulk first by ship and later by train. The system was based on warehouses in major cities. Straubs store, seen here in c. 1889, was located in Monterey. Courtesy of Monterey Public Library.

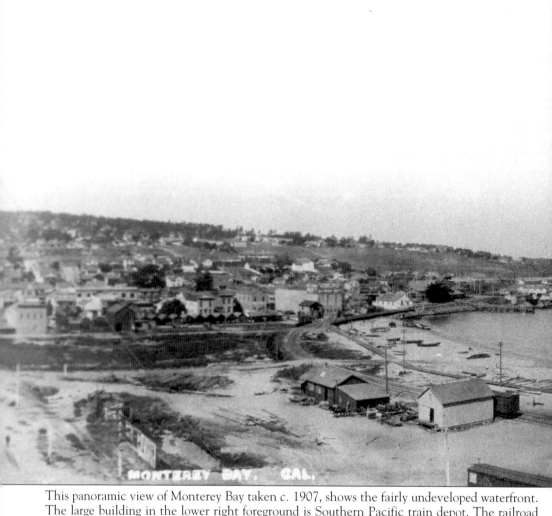

This panoramic view of Monterey Bay taken *c.* 1907, shows the fairly undeveloped waterfront. The large building in the lower right foreground is Southern Pacific train depot. The railroad was extended from Castroville to Monterey in January 1880. In 1889 service was extended to

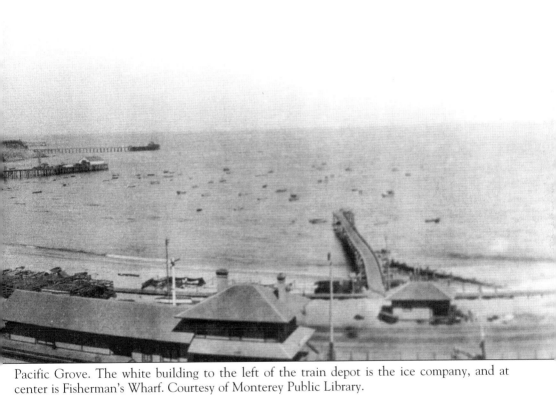

Pacific Grove. The white building to the left of the train depot is the ice company, and at center is Fisherman's Wharf. Courtesy of Monterey Public Library.

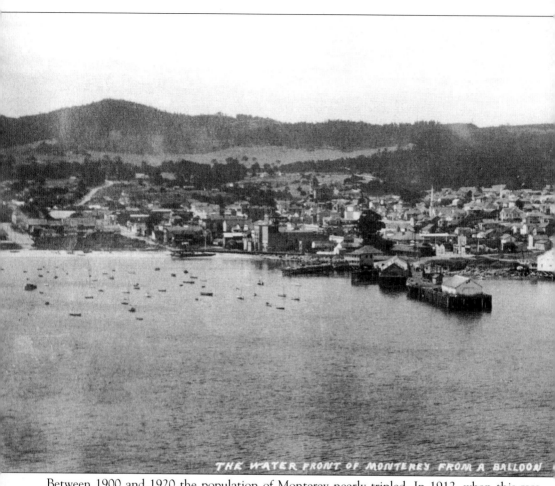

THE WATER FRONT OF MONTEREY FROM A BALLOON

Between 1900 and 1920 the population of Monterey nearly tripled. In 1912, when this rare aerial of Monterey was taken from a hot-air balloon, Old Monterey is beginning to look like a city. Right to left are Old Town, the Custom House, Fisherman's Wharf, Booth Cannery, and

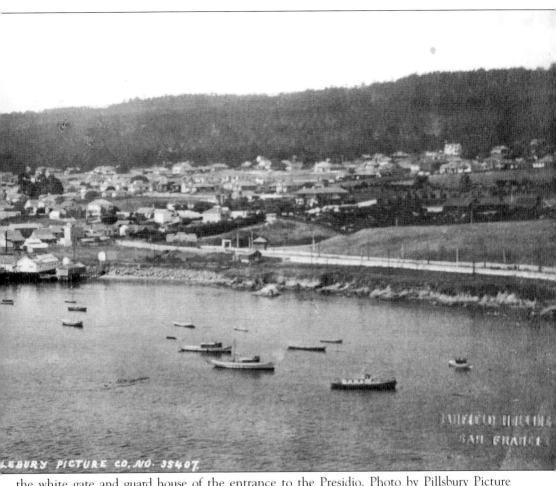

the white gate and guard house of the entrance to the Presidio. Photo by Pillsbury Picture Company, courtesy of Monterey Public Library.

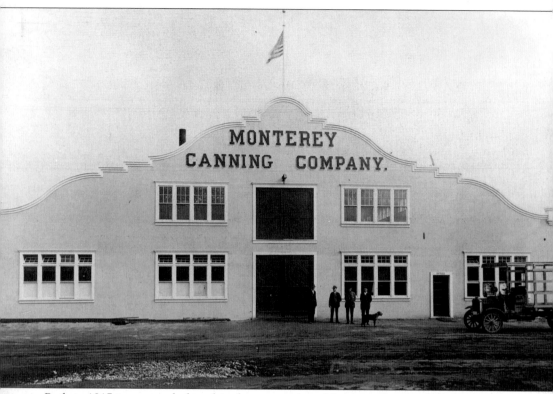

Built in 1917 just a year before this photo was taken, Monterey Canning Company was one of seven canning and reduction facilities in Monterey that packed a combined total of 1.4 million cases of sardines annually. It was located at Prescott Street and Ocean View (renamed Cannery Row in 1957), and built by owners A.M. Allen of Point Lobos and George Harper of Monterey. Courtesy of Monterey Public Library.

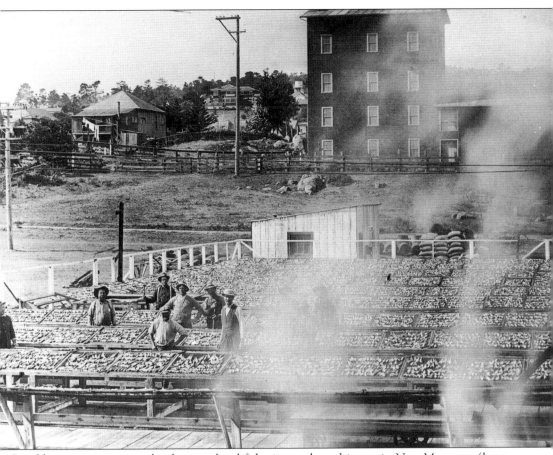

In addition to canning and reduction, local fisheries, such as this one in New Monterey (later Cannery Row), exported tons of seafood. Here fish is laid out to dry in the sun. Note the smoke in the foreground. This photo was taken c. 1920. Courtesy of Monterey Public Library.

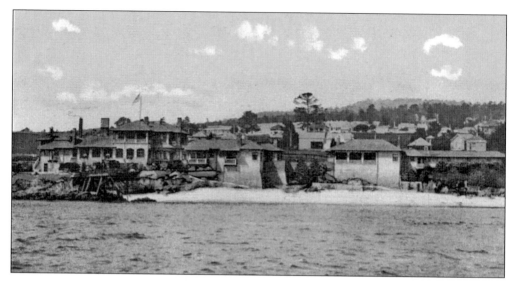

As has been discussed by Betty Hoag McGlynn, from 1901 to 1941, a single estate, *Casa de las Olas* or House of the Waves, occupied almost the entire eastern third of New Monterey's coast. It was built by Hugh Tevis, a Harvard-educated son of a prominent San Francisco lawyer who had vacationed at Hotel Del Monte with his family. Construction on the house began in 1900 (the architect was from San Francisco). It was located on Ocean View Boulevard (now Cannery Row), where the Monterey Plaza Hotel stands today,

The property also had a 50-foot bathhouse, a hot house, a bowling alley, a stable, and a 250-foot pier with ship launch was planned on the bay side. But Tevis died suddenly in 1901 on a trip to Japan with his new bride as they waited for their house to be completed. In 1904 the house was sold to David Jacks, who in turn sold it to Montana millionaire James A. Murray, who died in the home in 1921. The house remained in the Murray family until 1944 when it was razed and the property gave way to a cannery.

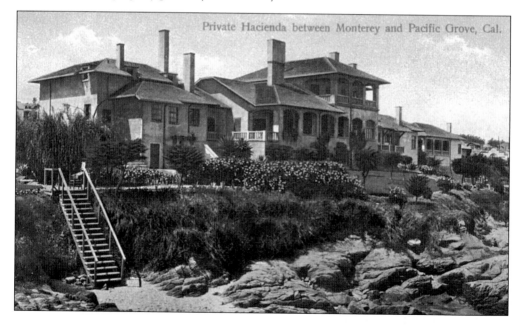

Private Hacienda between Monterey and Pacific Grove, Cal.

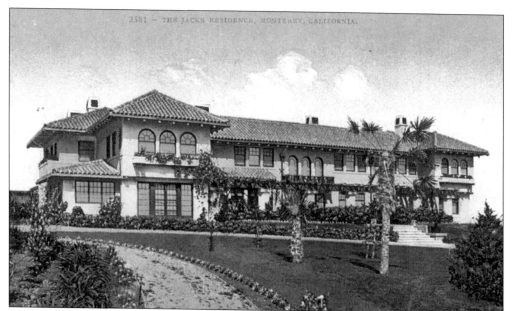

Born in Scotland, David Jacks arrived at Monterey in 1850 via New York and San Francisco. In 1859, amid much controversy and for the modest sum of $1,002.50, Jacks bought 30,000 acres of land from the city of Monterey, including the area that was to become Hotel Del Monte, as well as a large piece of land in Carmel Valley. Jacks' two-story Mediterranean-style estate at the end of Van Buren Street had an 180-degree ocean view of Monterey Bay.

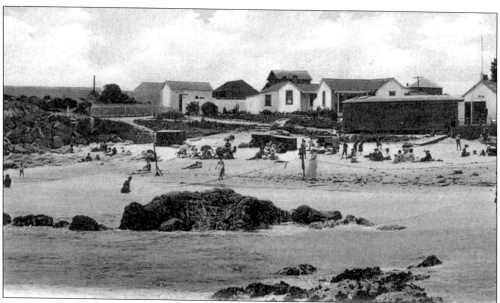

"Among the pleasure resorts around Monterey," states an 1899 souvenir booklet, "none are more popularly visited than the beautiful Macabee Beach, only a short distance from the center of the city. Mr. J.B. Macabee discovered this sandy spot, and about 10 years ago erected a bathhouse there, which is now the most extensively patronized resort in these parts." The bathhouse, according to the brochure, had 52 rooms, a refreshment stand, 500 feet of beach frontage, and "convenient lounging places, with light-covered awnings."

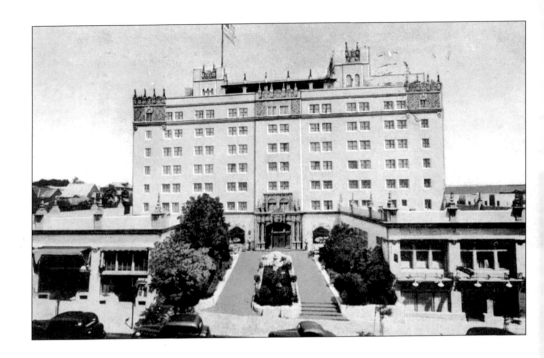

Hotel San Carlos (opened October 6, 1926), a nine-story structure that covered almost an entire city block dominated the skyline in downtown Monterey for many years. The interior was designed in the spirit of the grand resort hotels but on a city scale. Located in the heart of Monterey, it was the only large, luxury hotel within the city. It was demolished in February 1983.

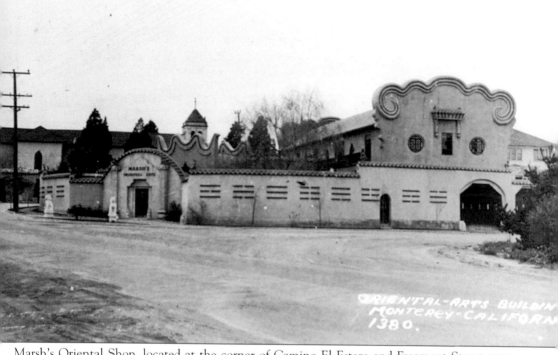

Marsh's Oriental Shop, located at the corner of Camino El Estero and Freemont Street, was built for Australian-born George Turner Marsh (1857–1932). Marsh, who was an antique dealer and importer with stores in San Francisco, Santa Barbara, and Los Angeles, opened the Monterey shop in 1928.

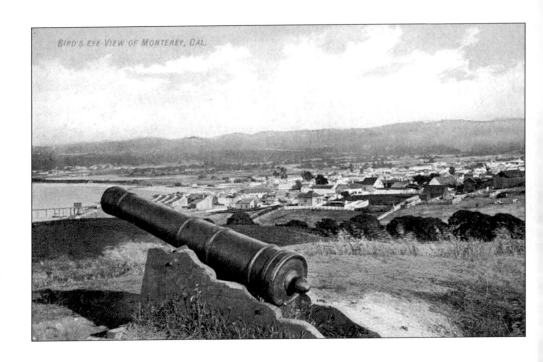

This view shows Monterey harbor from near the site of El Castillo (above), the original Spanish fort. Cannons were erected in 1792 to protect the town from invading ships. Later, barracks were built to house army troops (below).

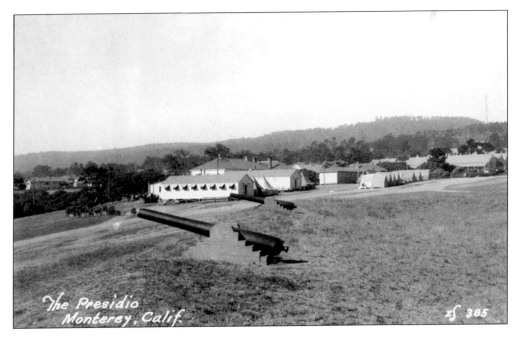

The Presidio
Monterey, Calif.

385

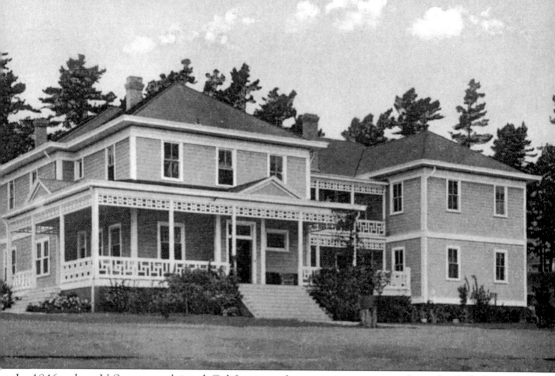

1148 – Officers' Club, Presidio of Monterey, California.

In 1846, when U.S. troops claimed California, a fortress was constructed on the hill above where the Spanish had set up an outlook fortified with several cannons. It was called Fort Mervine, but it fell into disrepair when the American army left the area in 1865. In 1898, when the U.S. entered into war with Spain, the fort was reactivated, and in 1904 it was officially named the Presidio of Monterey. Since then it has been the home of infantry, artillery, and cavalry regiments. In the 1940s the Presidio was a town within a town, with a stadium, movie theater, recreation hall, swimming pool, tennis courts, polo field, hospital, supply stores, barracks for enlisted men, officers' homes, and a stately officers' club (seen here).

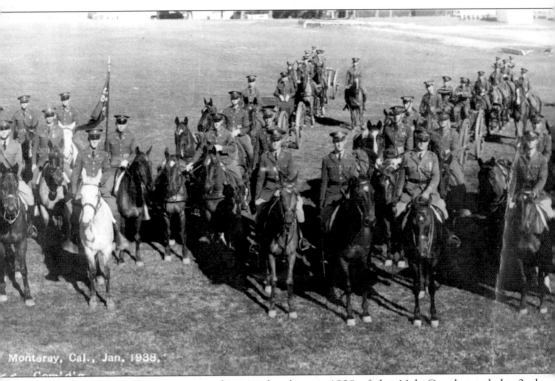

Monterey, Cal., Jan. 1938.

This is a detail of a panoramic photograph taken in 1938 of the 11th Cavalry and the 2nd Battalion, 76th Field Artillery, at the Presidio of Monterey, when Major Theo. E. Weiden was in command. The cavalry remained at the Presidio until 1940. During World War II, Monterey (including Fort Ord) became one of the military's largest training centers. Courtesy of Monterey Public Library.

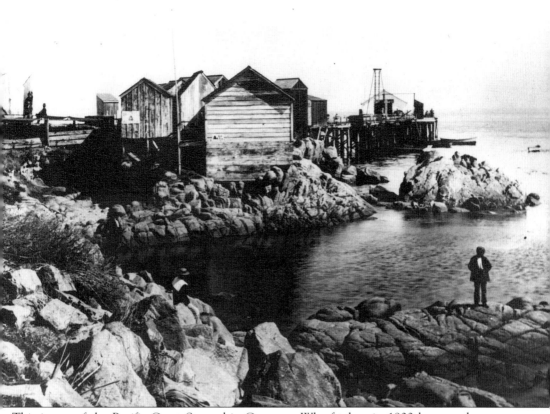

This image of the Pacific Coast Steamship Company Wharf taken in 1900 by an unknown photographer shows the rarely photographed east side of the wharf. Courtesy of Monterey Public Library.

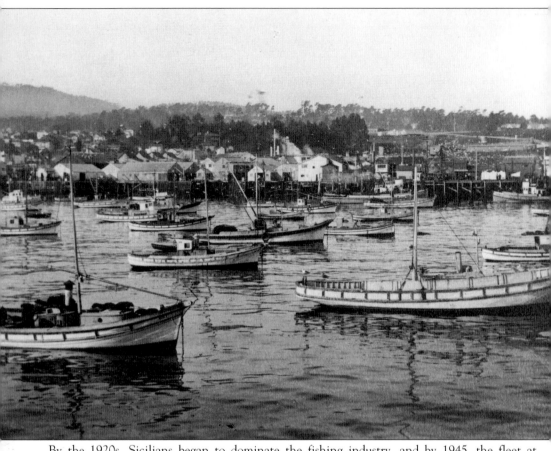

By the 1920s, Sicilians began to dominate the fishing industry, and by 1945, the fleet at Monterey had grown to over 100 vessels. Photo by Albert DeRome, *c.* 1940. Courtesy of Monterey Public Library.

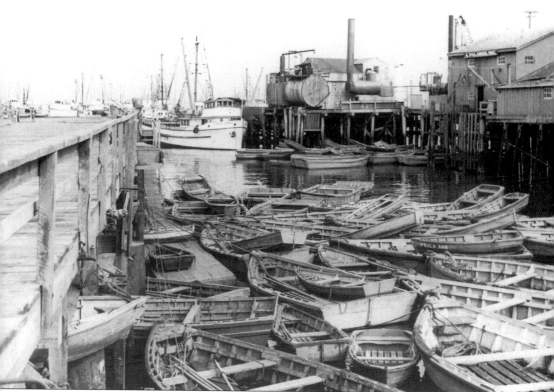

In 1930, the annual sardine catch in the Monterey Bay was recorded at 159,000 tons. By 1948, the catch had dwindled to 14,000 tons. Different reasons for the disappearance of the sardines are argued, among them over-fishing. This photo of Fisherman's Wharf was taken c. 1940 by Albert DeRome. Courtesy of Monterey Public Library.

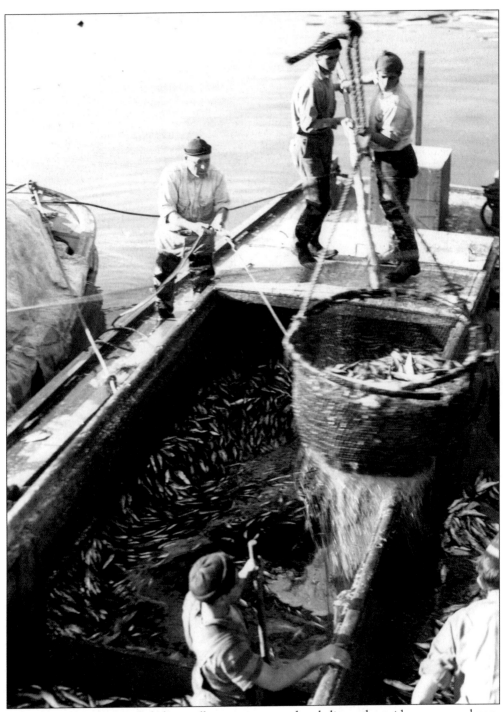

Monterey's abundance of abalone, albacore tuna, mackerel, lingcod, squid, snapper, salmon, and sardines made commercial fishing a mainstay of the economy. At its peak, Cannery Row was home to some 19 canneries and 20 reduction plants. This photo shows sardines being unloaded into a hopper in October 1937. Photo by William Morgan, courtesy of Monterey Public Library.

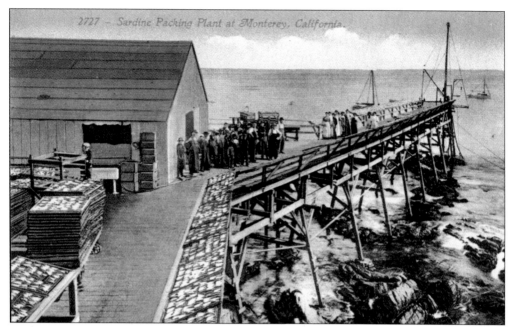

Sicilians were the dominant fleet owners in the early 1940s, by which time they were using purse seiner boats. These vessels were larger and had more capacity than the boats they had introduced to Monterey after the turn of the century.

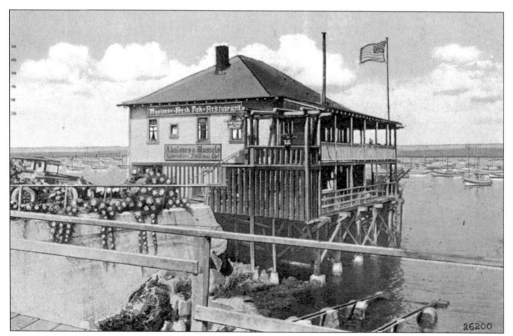

Pop Ernest's restaurant on Fisherman's Wharf was known for its tender abalone. Ernest, who supported the law that limited the amount of abalone harvested and closed the season during breeding, is said to be the originator of the abalone steak.

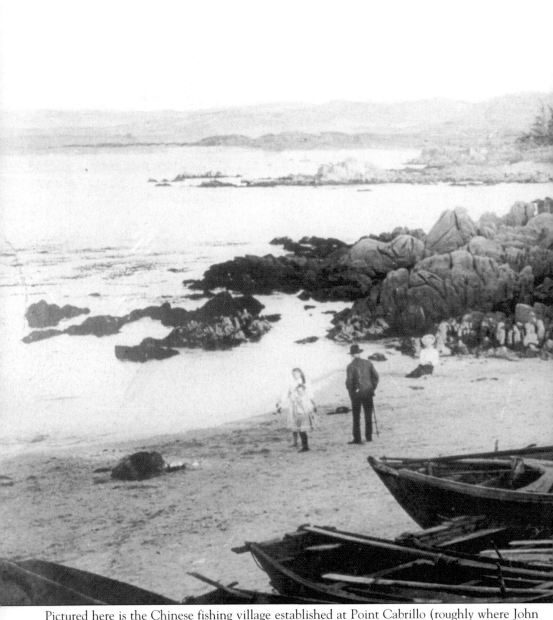

Pictured here is the Chinese fishing village established at Point Cabrillo (roughly where John Hopkins Marine Station is today) in the 1850s. A guidebook published in 1875 describes it as "about one mile from the outskirts of town, and situated on one of the numerous small bays that line the bay of Monterey. . . . The Chinese industries are fishing for rockfish, cod, halibut, flounder, red and blue fish, yellow tail, mackerel, sardines, and shell fish, the greater part of which are split open, slated, and dried in the sun for exportation to San Francisco, whence they find their way to the mines throughout the state, and abroad. . . . They possess 30 boats [junks],

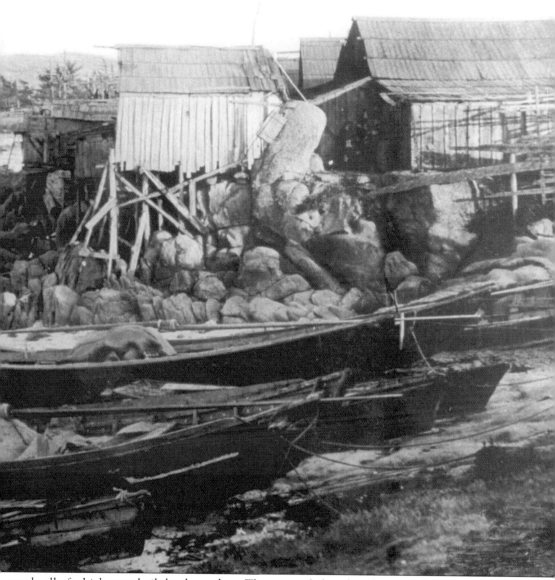

nearly all of which were built by themselves. They are sailed in the Chinese fashion."

The village was a one-street assembly of wooden lean-tos, where as many as 100 Chinese fishermen lived by the 1870s. Not popular with neighbors and slated for development by the Pacific Improvement Company in 1905, the Chinese refused to vacate. In May 1906, after a protracted struggle, the village burned and the members of the Chinese community were scattered. This photo was taken c. 1900. Courtesy of Monterey Public Library.

PACIFIC OCEAN

Moss

Monterey Peninsula Country Club

Pt. Joe

1600 Acres of Forest & Sea Shore

Bird Rock

Seal Rock

Fan Shell Beach

Cypress Pt.

Sunset Pt.

Midway Pt.

Published by Del Monte Properties in c. 1929, this map of Monterey, Pacific Grove, and Pebble Beach illustrates the picturesque quality of the peninsula's geography. By contrast, the plan for

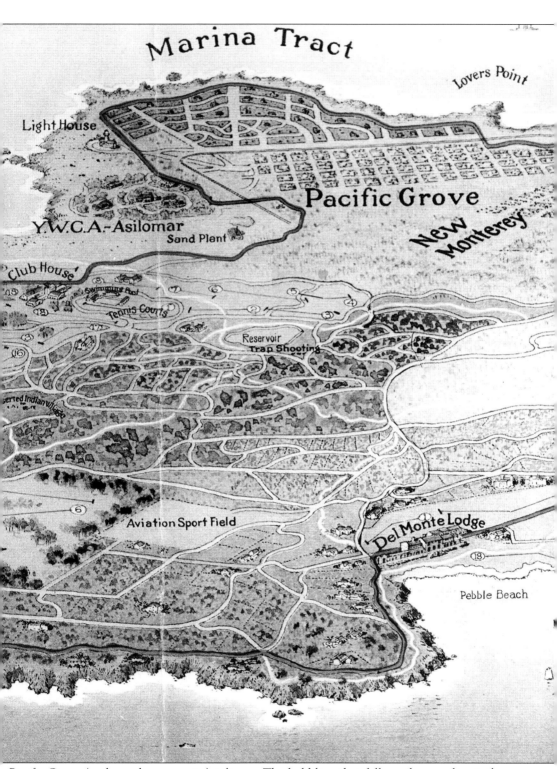

Pacific Grove (a planned community) is linear. The bold line that follows the coastline is the 17-Mile-Drive. Courtesy of Monterey Public Library.

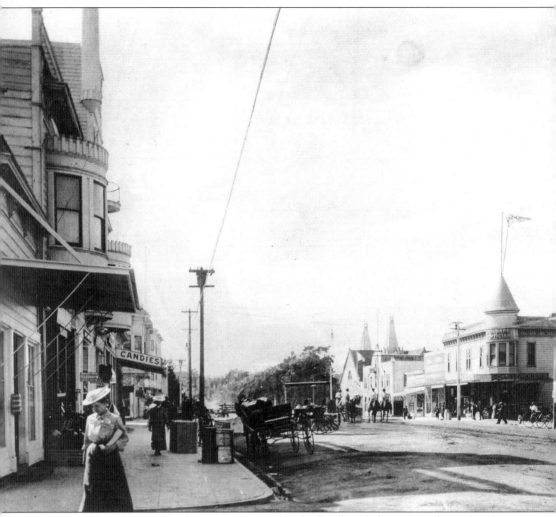

The preferred era of architecture in the Methodist-founded retreat of Pacific Grove was Victorian. By 1890, when this photograph was taken, Lighthouse Avenue, first laid out in 1874 as a route to the town's lighthouse, was complete on both side with Queen Anne and Stick-Style commercial buildings. Courtesy of Monterey Public Library.

Two

PACIFIC GROVE

"I walked through street after street . . . paved with sward and dotted with trees," wrote Robert Louis Stevenson describing Pacific Grove, "but still undeniable streets, and each with its named posted at the corner, as in a real town. . . . I saw an open-air temple, with benches and sounding board, as though for an orchestra. The houses were all tightly shuttered; there was no smoke, no sound but of the waves, no moving thing. . . . Indeed it was not so much like a deserted town as like a scene upon the stage by daylight, with no one on the boards. . . . Tither, in the warm season, crowds come to enjoy a life of teetotalism, religion, and flirtation, which I am willing to think blameless and agreeable."

Originally a retreat funded by the Methodist Church on property donated by David Jacks, Pacific Grove became a Mecca for those seeking a small town existence. For many years the town was separated from Monterey by a fence with a locked gate. In the late 1880s and early 1890s, however, large, two-story Victorian homes were built on small lots originally divided for summer retreat campers and their tents.

In 1920 the citizens of Pacific Grove passed an ordinance that read: "It is hereby declared to be unlawful for any person while dancing to assume or maintain any position which tends in any way to corrupt the good morals of any person attending said dance hall. . . . Dances known as the tango, turkey trot, bunny hug, or shimmie are hereby prohibited . . . "

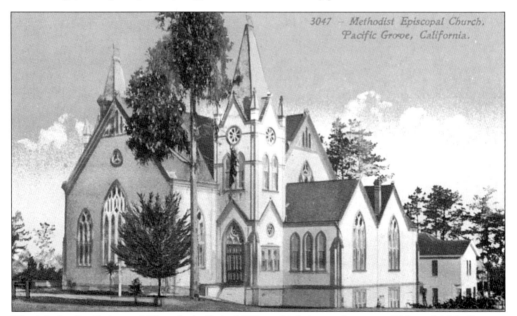

The Methodist Episcopal Church, built in 1888 on Lighthouse between 17th and 18th Streets, was a vision of Victorian Gothic Revival splendor until it was demolished in 1964.

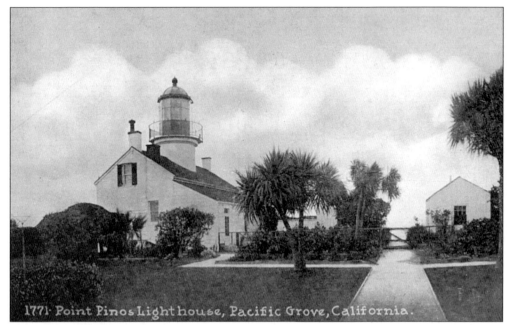

1771 Point Pinos Lighthouse, Pacific Grove, California.

Point Pinos Lighthouse, originally built in 1853, "is situated on an eminence and point of land forming the extreme western shore of the bay of Monterey," stated an 1875 guidebook. "The light is classed," the guidebook continued, "as a third order Fresnel, with catadioptric lenses." First illuminated by a whale-oil lamp, the lighthouse was electrified in 1919.

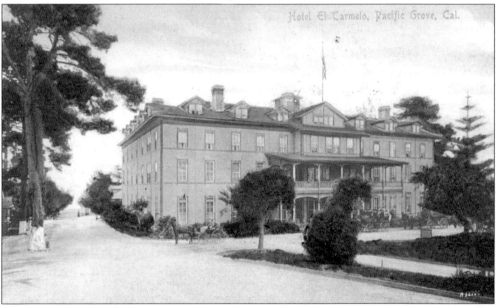

Hotel El Carmelo, Pacific Grove, Cal.

Built by the Pacific Improvement Company in 1887 in the wake of the fire that destroyed Hotel Del Monte, the El Carmelo Hotel (sometimes called the Pacific Grove Hotel), was located on Grand and Fountain Avenues. It had 114 rooms and was a "more retired and less expensive vacation place than Del Monte." Guests could, however, use the facilities at Hotel Del Monte after it was rebuilt. The hotel was demolished in 1919 and the lumber was reused in the constructions of the Lodge at Pebble Beach.

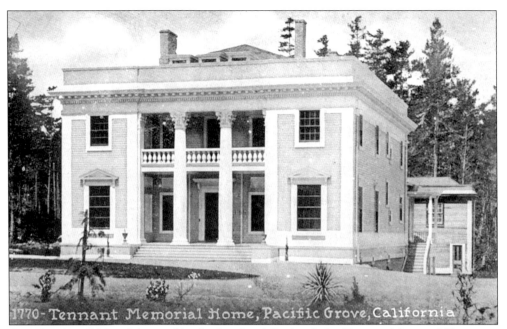

1770 - Tennant Memorial Home, Pacific Grove, California

Completed in 1896 and designed by Coxhead and Coxhead, the Tennant Memorial Home was a gift of Margaret Tennant to the Episcopal Diocese. This classically inspired structure at Sinex and Forest Avenues was demolished in 1965.

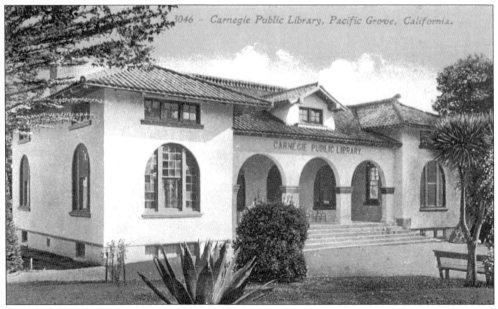

3046 - Carnegie Public Library, Pacific Grove, California.

The Carnegie Public Library in Pacific Grove, founded in 1907–08, was one of many small community libraries across the U.S. built with funding from Andrew Carnegie, who gave $10,000 to its construction. It was designed by William Henry Weeks of Watsonville, California, who also designed the Pacific Grove Post Office (1907) and Pacific Grove High School (1911), as well as many buildings in Monterey. Architecturally the library resembles a miniature Italian villa.

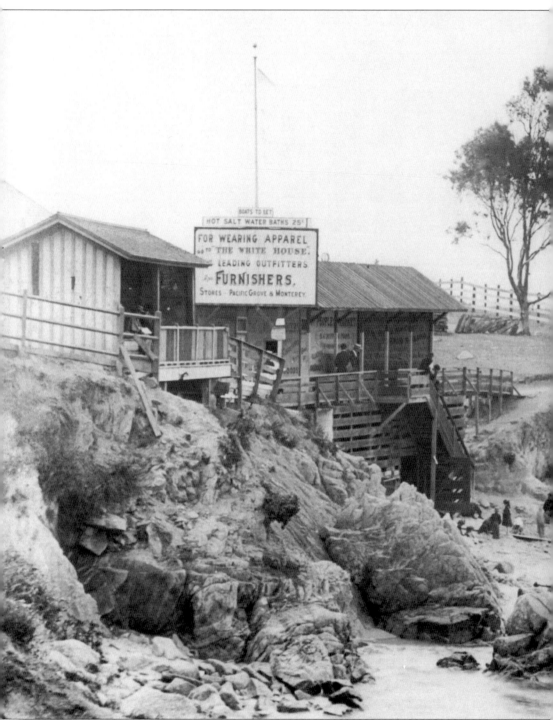

The bathhouse at Lover's Point (left) was a main attraction for summer residents of Pacific Grove. The Hopkins Seaside Laboratory (right) was built in 1892, close to the date of this photograph. It was named for its benefactor, Timothy Hopkins, son of Mrs. Mark Hopkins. In December 1916 in a land swap arrangement with the Pacific Improvement Company, Stanford

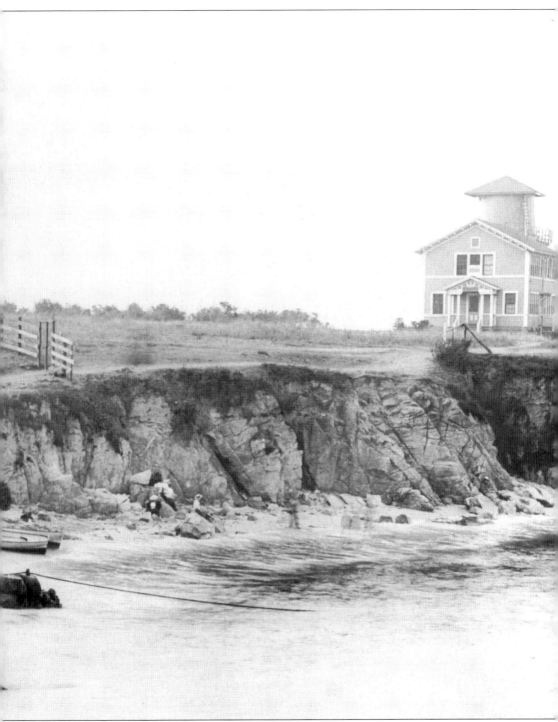

University, which owned and operated the lab, relocated to China (or Cabrillo) Point. In 1917, a new building was constructed at China Point and the lab was renamed Hopkins Marine Station. Courtesy of Monterey Public Library.

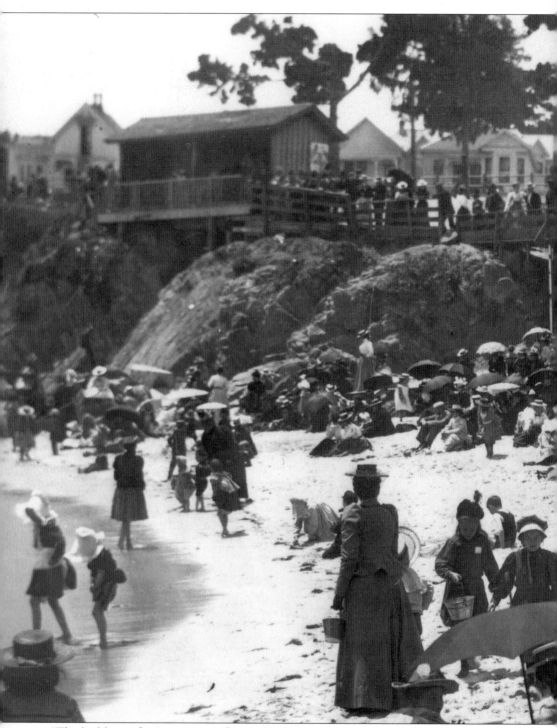

"The bathhouse [at Lover's Point] is 60 by 24 feet, and contains 22 dressing rooms," stated a guidebook in 1875. "It is conveniently placed in a small ravine on the verge of a beautiful little bay, whose sandy floor rivals in whiteness the marble of the Romans' baths." Blue Laws in Pacific Grove strictly forbid exposing oneself. Bathing suits were required to have "double

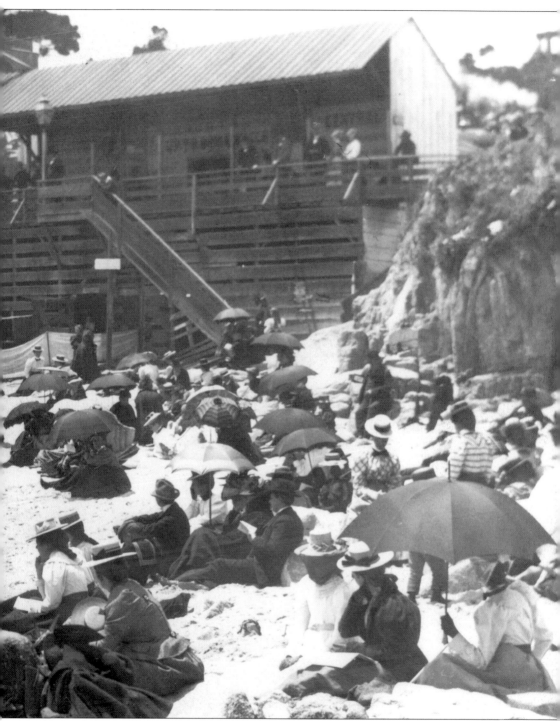

crotches or a skirt of ample size to cover the buttocks." This photo of sunbathers (covered from head to toe as was the law) in *c.* 1898 was taken by Joseph K. Oliver. Courtesy of Monterey Public Library.

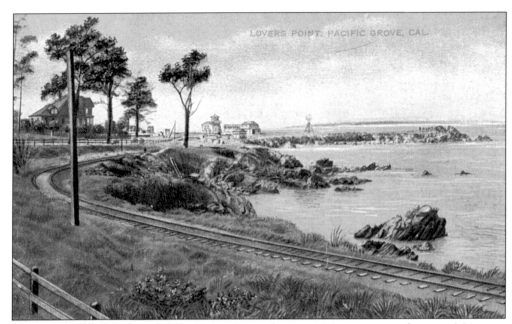

The tracks of the Southern Pacific Railroad, seen here, were first put to use between Monterey and Pacific Grove in 1889. Service continued until 1957.

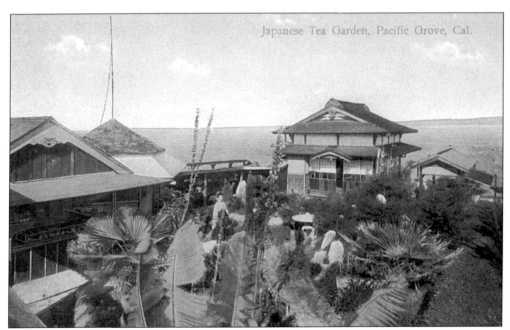

In 1904, a Japanese Teahouse complete with gardens was built at Lover's Point. Visitors could have a tea ceremony and enjoy small cakes and other sweets. The teahouse survived only until 1918.

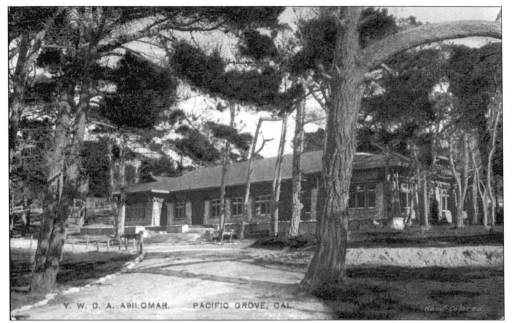

Asilomar, built in 1913 for the Young Women's Christian Association, was founded under the auspices of Phoebe Apperson Hearst, a philanthropist and the mother of William Randolph Hearst. It was designed by Ecole des Beaux Arts-trained architect Julia Morgan, who also was architect of Hearst's estate complex in San Simeon, California. In 1916, Morgan designed a house for Pacific Grove resident Lena Dinsmore at 104 First Street. Morgan's local studio was at 373 Cedar Street in Monterey.

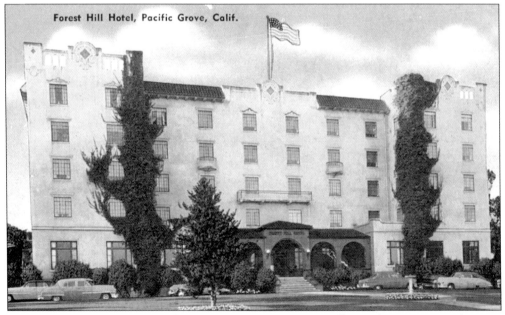

Owned by Samuel Parsons and built in 1925, the Forest Hill Hotel was converted into a retirement home in the 1950s. When it was built, it was among the largest buildings and still commands a 180-degree view.

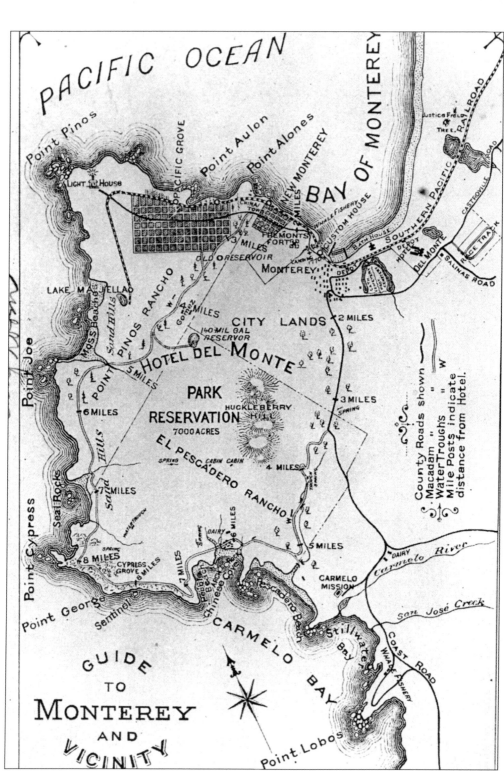

This map of the Monterey Peninsula from an 1886 guidebook, shows the original boundaries of the El Pescadero and Point Pinos ranches Courtesy of Monterey Public Library.

Three
PEBBLE BEACH

El Rancho, El Pescadero, and Rancho Punta de Pinos, the two original land grants that make up Pebble Beach, were purchased from David Jacks in the early 1880s by the Pacific Improvement Company. In 1915, Samuel F. B. Morse, a distant relative of the inventor of the telegraph, was hired to manage and liquidate the holdings of the company. Morse began by dividing much of Pebble Beach into five-acre lots. Many sold, but the ambitious young Morse quickly changed his mind and bought back all but one of the lots. Morse "dreamed of a resort community as synonymous with golf as Pinehurst," wrote Neal Hotelling in his recent book. "Accordingly, he deemed that the southern shoreline would serve better as a golf course than a series of residential lots." Construction of the "links," as the course was called, began in 1916 under the direction of champion amateur golfer Jack Neville. In 1919 Morse began to personally acquire some of the Pacific Improvement Company's prime holdings including "18,000 acres of land . . . all of Pacific Grove and Pebble Beach areas . . . Los Laureles Rancho . . . Hotel Del Monte . . . [and the] capital stock of the Monterey County Water Works" as Morse described it in a letter to a friend.

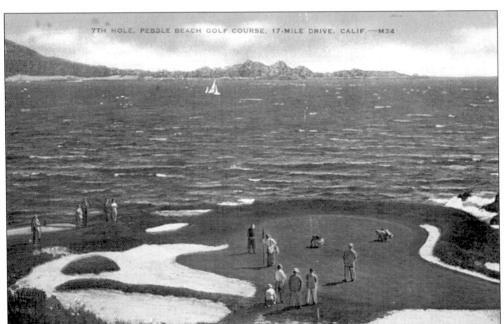

Pebble Beach is arguably the most scenic golf course in the world.

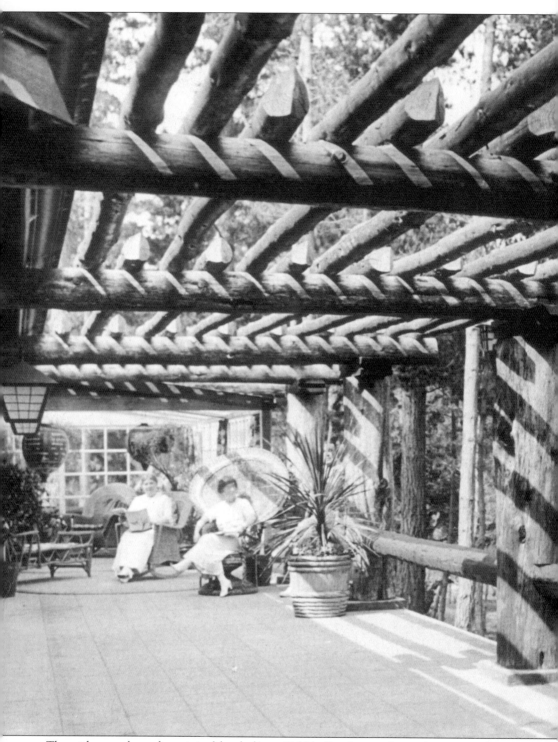

The wide pergola at the original log lodge at Pebble Beach served as a destination for visitors to the forest. It was built in 1909, burned in 1918, and replaced a year later by today's Lodge at Pebble Beach. In an interesting adaptation, the pergola, a classical feature, is built from

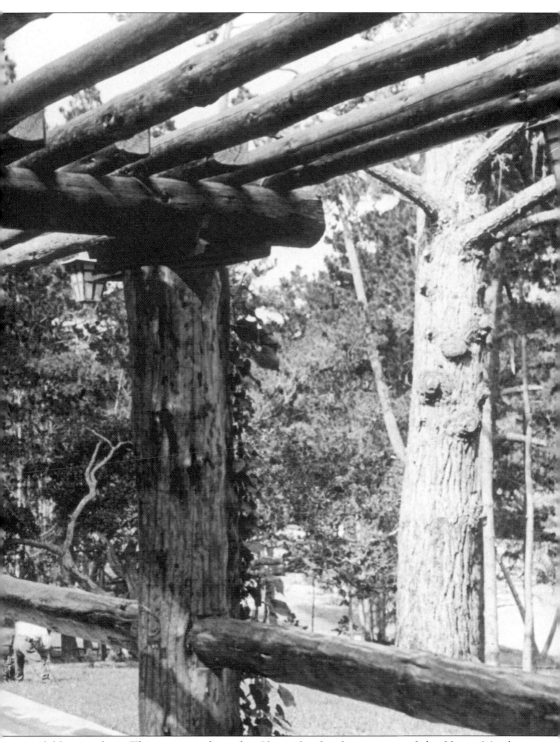

available pine logs. This image is from the Chappelet family, courtesy of the Henry Meade Williams Local History Department, Harrison Memorial Library, Carmel, CA.

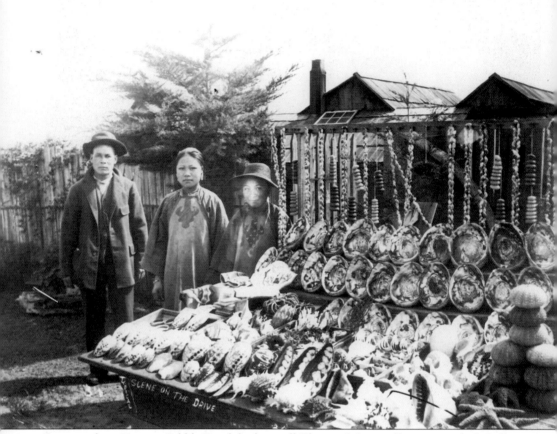

For more than 40 years, Pebble Beach had a small Chinese fishing village near today's Stillwater Cove. It included this souvenir stand owned by Jung San Choy, pictured here with his wife. This image was taken by Joseph K. Oliver, himself an expert conchologist, in c. 1895–1900. A dozen years later the village was demolished. Courtesy of Monterey Public Library.

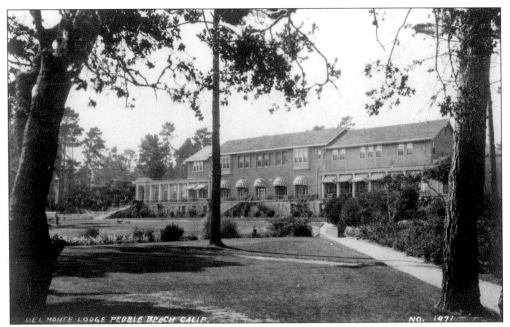

Established architects Lewis Hobart and Clarence Tantau were engaged to design a modern "clubhouse" in place of the log lodge at Pebble Beach. Completed in less than a year using lumber from the demolished Pacific Grove Hotel, the new lodge was in keeping with what Samuel F.B. Morse had in mind for his soon-to-be elegant golf resort.

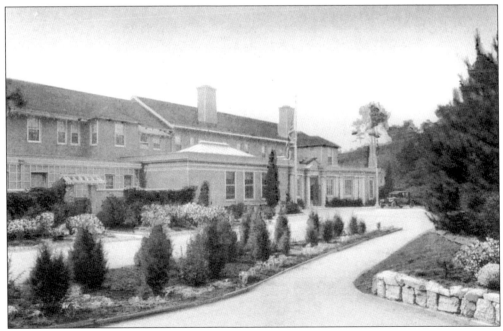

The east facing entrance façade of the Lodge at Pebble Beach.

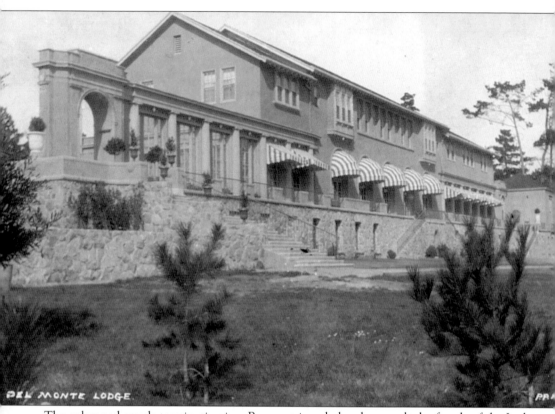

DEL MONTE LODGE.

The columned arcade terminating in a Roman triumphal arch extends the façade of the Lodge at Pebble Beach beyond the main building, visually balancing the series of windows on the right side. The stone foundation and stairways between the terrace and the fairway manage the change in grade from the back of the building to the front in the style of an Italian villa.

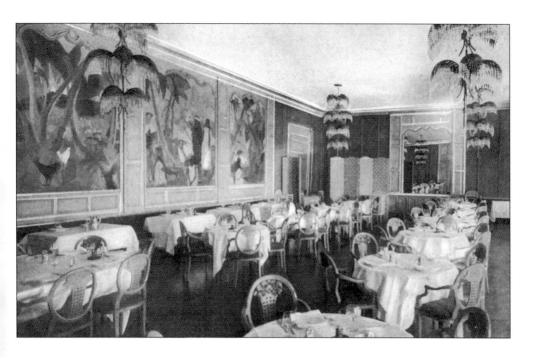

The interior of the dining room (above) of Lodge at Pebble Beach included murals by local artist Francis McComas (who also played a role in redesigning several golf holes, most notably #14), and interiors by designers Elsie de Wolfe of the east coast and Frances Elkins, who moved to Monterey from Chicago. The Terrace Lounge (below) had a view out over the golf course and across the bay to Point Lobos.

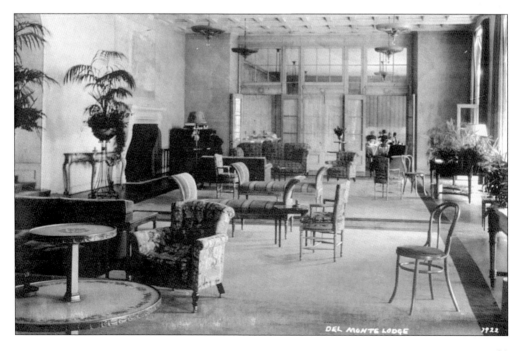

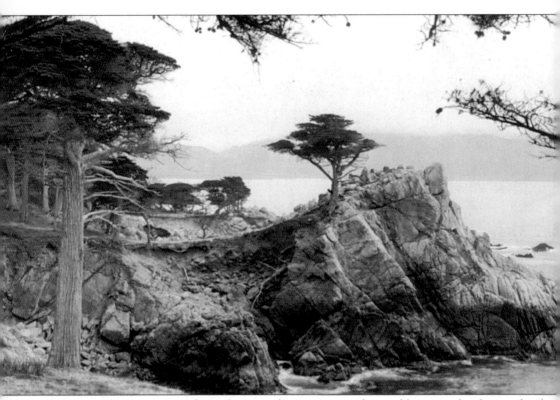

The Lone Cypress tree, perhaps the most famous tree in the world, is seen by thousands of tourists each year. This particular variety of cypress, *Cupressus macrocarpa*, grows only on the shore of Carmel Bay, and never more than 350 feet from the water. Today the Lone Cypress is the logo of the Pebble Beach Corporation.

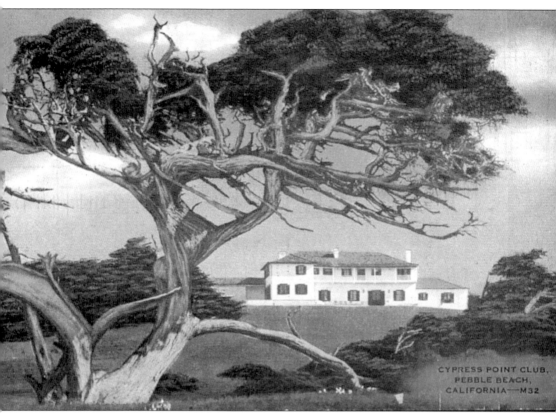

CYPRESS POINT CLUB,
PEBBLE BEACH,
CALIFORNIA—M32

The Cypress Point Club at Pebble Beach is among the country's most exclusive private golf clubs. It was the brainchild of Samuel F.B. Morse and Marion Hollins, the athletic director at Pebble Beach. Hollins hired legendary Scottish golf architect Alister MacKenzie to design the course and the famous Olmsted Brothers to develop a landscape master plan. Construction on the course began in 1927 and was completed nine months later in 1928, when the first round was played. The clubhouse was designed by the equally famed Harvard trained George Washington Smith, who had designed many notable homes in Santa Barbara and Montecito, California. It was completed in 1930, the year Smith died. Smith also designed homes in Pebble Beach for Paul Fagan and Mrs. Arthur Hately.

On 17 Mile Drive, Pacific Grove, Cal.

Seventeen-Mile Drive was so named because it was the roundtrip distance from Del Monte Hotel to Pebble Beach via Pacific Grove and Monterey. The scenic drive first navigated by horse and buggy in the 1980s and later by automobile, was a favorite attraction for visitors.

The fairways at Pebble Beach Links are perhaps the most photographed and challenging in the world.

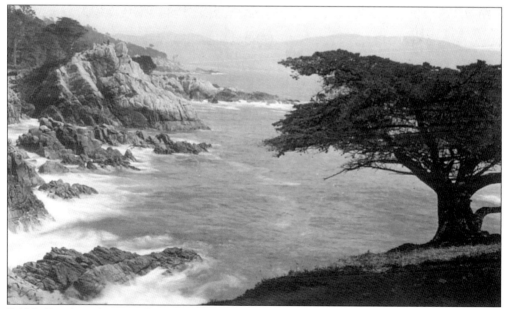

Pebble Beach is almost as famous for its trees as for its golf courses. Two types of tree are found only on the Monterey Peninsula—the Monterey cypress (*Cupressus macrocarpa*) and the Monterey pine (*Pinus radiata*). Long exposure to coastal winds deforms the cypress trees giving them their unique mystique. Robert Louis Stevenson wrote that the forest of Pebble Beach was the "kind of wood for murderers to crawl among . . . long aisles of pine-trees hung with Spaniard's Beard."

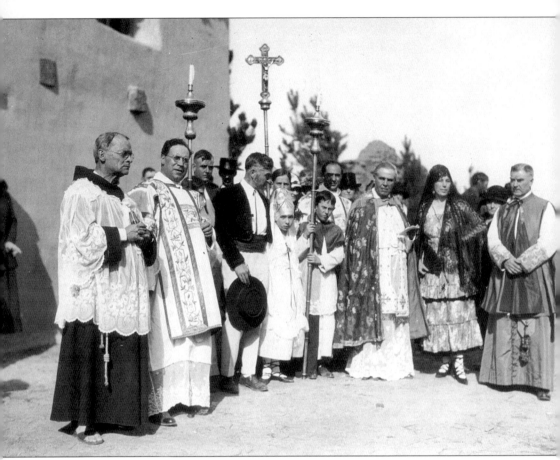

The first restoration of Mission San Carlos Borroméo de Carmelo was undertaken in 1884. In 1924, another restoration was completed, and a sarcophagus depicting Father Junípero Serra created by Art Student League trained artist Joseph Jacinto Mora was dedicated. Pictured here on October 12, 1924, in period attire from right, are artist Joseph Mora and his wife Patty Mora, Father Raymond Mestres, and other unidentified guests at the dedication ceremony. Courtesy of the Henry Meade Williams Local History Department, Harrison Memorial Library, Carmel, CA.

Four
CARMEL

On December 16, 1602, Don Sebastían Vizcaíno landed at Monterey. Two Carmelite friars on the expedition requested that the valley over the hill be named Carmelo in honor of their religious order. It was at this venerated site in 1771, a year after founding Mission San Carlos Borreméo de Carmelo near the presidio at Monterey, that Father Junípero Serra relocated and rebuilt his mission. The new location had the advantage of being on the fertile marshland near the mouth of the Carmel River and away from military domination.

Incorporated 1916
1920 Population 638
1930 Population 2,260
1940 Population 2,837

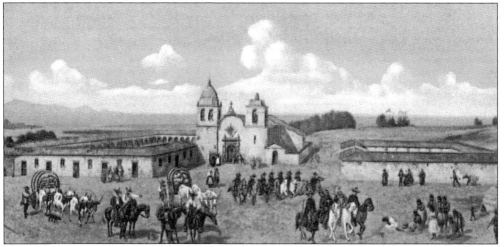

Mission San Carlos Borreméo de Carmelo was the second founded during California's Spanish period. The original mission compound included storerooms, quarters for friars, a kitchen, a workshop, and gardens.

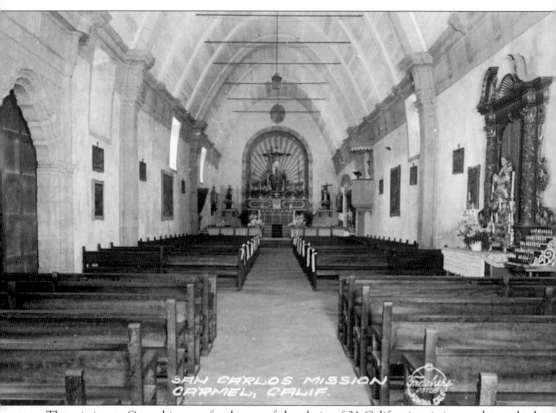

SAN CARLOS MISSION
CARMEL, CALIF.

The mission at Carmel is one of only two of the chain of 21 California missions to be vaulted, the other being at San Juan Capistrano. Its interior Doric frieze and Carmel stone construction are also unusual.

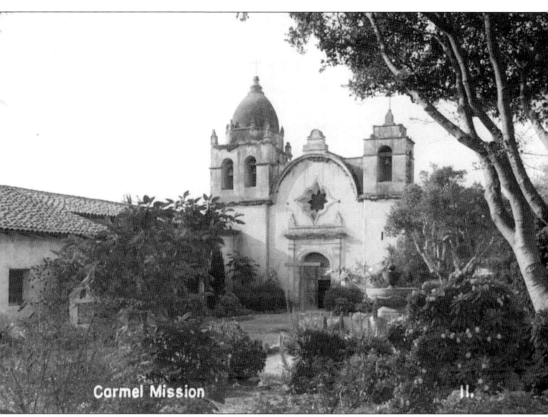

Carmel Mission 11.

In 1936 the mission underwent its third restoration, this time led by local tradesman Harry Downie, who brought the mission back to something closer to its original appearance. The Mission Order (or scalloped) Gable with a quatrefoil window at the center, flanked by stepped asymmetrical belfries—one of them domed—make this an unparalleled architectural success.

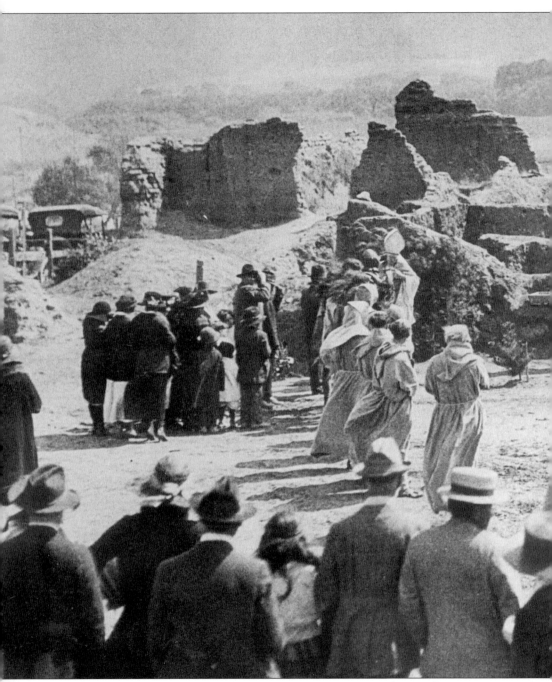

Mission San Carlos Borroméo de Carmelo lay in ruins in 1879 when Robert Louis Stevenson visited the site. "A ruined mission . . . there is no one left to care for the converted savage," he wrote. "The church is roofless . . . an antiquity in this new land." Father Serra himself described the mission built by four Indians, three marines, and four soldiers as a "stockdale of rough timbers, thick and high, with ravelins in the corners. [It is] closed at night with a key, although it is not secure because of the lack of nails." A guidebook dated 1875 described the mission in even less favorable terms: "Descend the hill, turn to the right, and we have reached the ruins

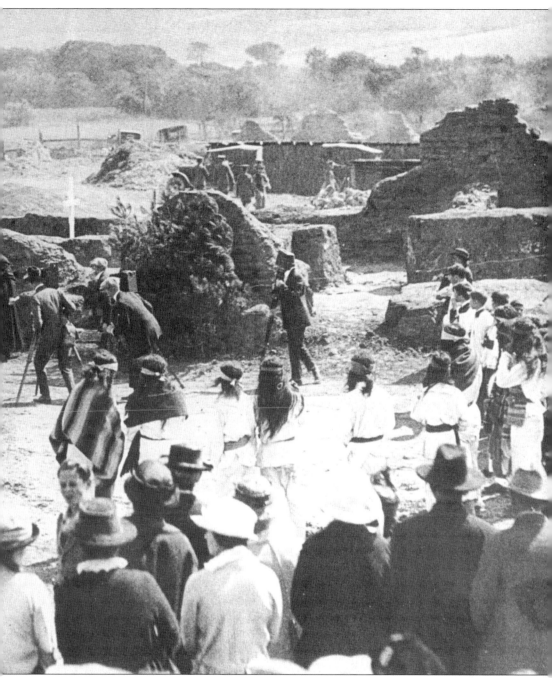

of the old Mission. Hardly a pleasing sight. . . . A few ruined, broken-down adobes encircle a dreary, desolate, semi-roofless building, beautiful even in decay—all that is left of the second Mission in California, and one that in its day must have been a grand edifice. . . . "

Pictured here is the cornerstone laying ceremony at Mission San Carlos Borroméo de Carmelo October 21, 1921, when the mission was rebuilt after years of decay. Courtesy of the Henry Meade Williams Local History Department, Harrison Memorial Library, Carmel, CA.

In the late 1880s developer/investor Santiago J. Duckworth (seen here) created a successful real estate venture selling lots in an area near the mission at Carmel, which he envisioned as a Catholic summer retreat. By the mid 1890s, he had sold some 200 lots when the bottom fell out of the real estate boom and the notion of a retreat was abandoned. Duckworth was the grandson of Tio Armenta, a retired soldier and one-time owner of Point Pinos. He was born in Monterey in 1862, son of Walter Duckworth, an English sailor. In the 1890s he was city of Monterey assessor. Courtesy of the Henry Meade Williams Local History Department, Harrison Memorial Library, Carmel, CA.

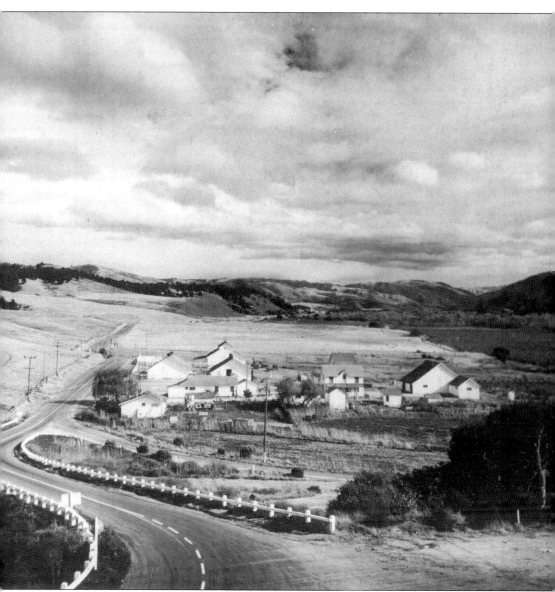

"One of the greatest industries in Central California," stated an 1899 guidebook, "and one of which this community is justly proud, is the Del Monte Creamery, owned by Mrs. Kate H. Hatton, about five miles from Monterey, in *el valle del carmelo*, one of the richest valleys in the state." Kate's husband, William Hatton, who came to Monterey in 1870, originally operated the dairy. "There are about 2,200 acres of land in the tract," the guidebook continued, "devoted principally to grazing, besides crops of corn and pumpkins being raised for winter feed." The Hattons' dairy (seen here in 1947), at the mouth of Carmel Valley, was one the principal suppliers of milk and butter to the Peninsula. Photo by George Seidneck, courtesy of Monterey Public Library.

In 1910, the *Los Angeles Times* ran an article about Carmel's Bohemian inhabitants titled "Hot Bed of Soulful Culture, Vortex of Erotic Erudition: Carmel in California, where Author and Artist Folk are Establishing the Most Amazing Colony on Earth." At the time, the village was

little more than a few dirt roads as seen here in this *c*. 1906 photograph of the northwest corner of San Carlos Street and Sixth Avenue. Courtesy of the Henry Meade Williams Local History Department, Harrison Memorial Library, Carmel, CA.

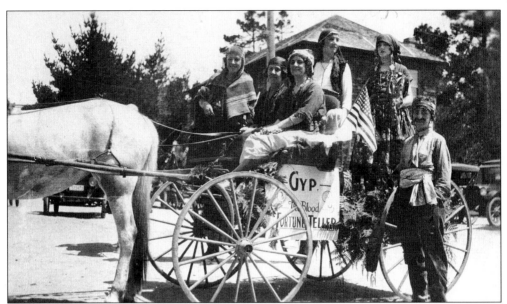

Organized as a fundraiser by the Arts and Crafts Club, the annual Sir-Cuss Day event featured theatrical performances by local celebrities. Here in the 1923 parade is Marion Shand, Kathryn Overstreet, Mrs. Appleton, Mrs. Schumacher, and Iris Alberto. Courtesy of the Henry Meade Williams Local History Department, Harrison Memorial Library, Carmel, CA.

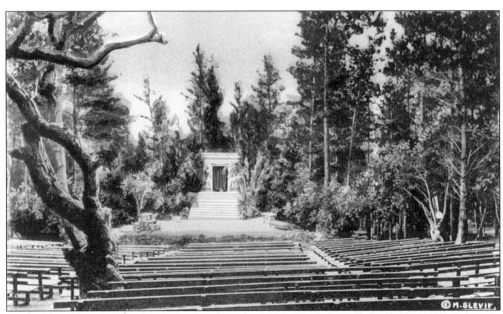

The open-air Forest Theater, conceived by playwright Herbert Heron in the first decade of the 20th century, was an immediate success. Plays were written by local writers, sets designed by local artists, and plays performed by residents. Nestled in the pine trees, it is considered the "first open-air community theater in California," and one of the most picturesque. Between 1937 and 1947 it was largely dormant (due in part to World War II blackout regulations). Courtesy of Monterey Public Library.

Starting in 1924, the Theater of the Golden Bough hosted a variety of live performances. It was destroyed by fire in 1935. Inside, the theater had a "projecting semi-circular platform connected to the main stage by a flight of wide shallow steps." Courtesy of Monterey Public Library.

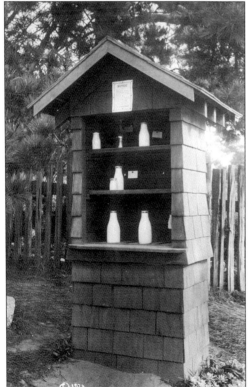

"The shelves are divided," wrote Daisy F. Bostick in 1925 of Carmel's milk shrines, "into pigeon holes with real or imaginary partitions separating them, and the name of the claimant to the space thumb-tacked to the back of the compartment. Here every evening gather the bottles, each with its exact 12¢ or neat little milk ticket." In the morning, residents could pick up their fresh bottle of milk. Photo by Louis Slevin, courtesy of the Henry Meade Williams Local History Department, Harrison Memorial Library, Carmel, CA.

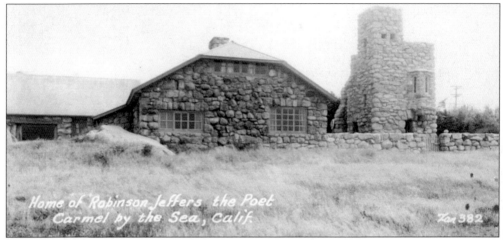

Home of Robinson Jeffers the Poet
Carmel by the Sea, Calif.

In 1913 poet Robinson Jeffers and his wife, Una Call Kuster, purchased five-acres at Carmel Point. "When the stagecoach topped the hill from Monterey and we looked down through the pines and seafog on Carmel Bay," wrote Jeffers, "it was evident that we had come without knowing it to our inevitable place." In 1919, the Jeffers completed the first section of Tor House, their Arts and Crafts-style house made entirely of native stone. A year later Jeffers designed and built, with his own hands, a 40-foot-high tower he called Hawk Tower; its view became the subject of many of his poems. Famous personalities such as Charlie Chaplin, Langston Hughes, George Gershwin, and Edna St. Vincent Millay were drawn to the peninsula to visit Jeffers at his home.

Painters and photographers were drawn to Carmel's charm and rustic beauty and to the bohemian lifestyle so carefully protected by its inhabitants. Among the most notable who either set up residence or made periodic stays were Ansel Adams, Arnold Genthe, Armin Hansen, William Ritschel, Edward Weston, and Xavíer Martinez.

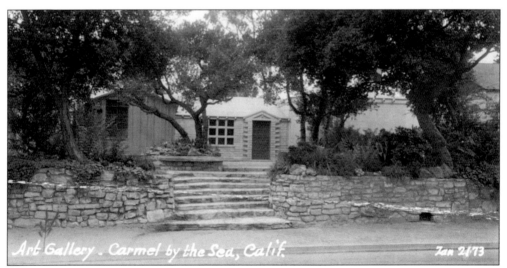

Art Gallery. Carmel by the Sea, Calif.

The Carmel Art Association was founded in 1927. Early members included Pedro J. Lemos, George Seidneck, Armin Carl Hansen, Josephine Culbertson, Myron Oliver, E.C. Fortune, C. Chapel Judson, De Neale Morgan, and others. Once the home of painter and playwright Ira Remsen, this house on Dolores Street was acquired by the members of the Association in the early 1930s and converted into galleries to showcase their art.

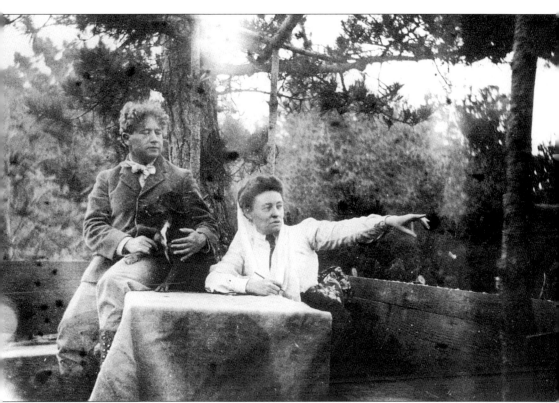

The local Bohemian set, which included Mary Austin (seen here in c.1910 with fellow author Jimmy Hopper in her "wick-i-up" treehouse across from her house at Fourth and Lincoln, where she preferred to write), George Sterling, and Jack London, spent many hours together and often met at the beach in Carmel for meals.

It was about their lifestyle that George Sterling, Sinclair Lewis (who was a visitor), and others penned the legendary lyrics "Oh some think that the Lord is fat,/And some that he is bony/ But for me, I think that he/Is like an abalone. . . . Oh some drink rain and some champagne,/And whisky by the pony/But I will try a dash of rye/And a hunk of abalone. . . . Oh some folks boast of quail on toast/Because they think it's toney, /But I'm content to pay my rent/And live on abalone." Courtesy of the Henry Meade Williams Local History Department, Harrison Memorial Library, Carmel, CA.

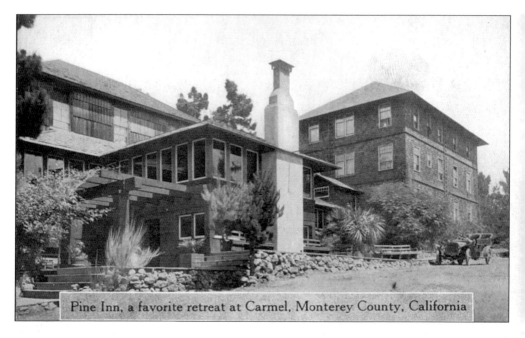

Pine Inn, a favorite retreat at Carmel, Monterey County, California

In 1903, the Hotel Carmelo, established by Santiago. J. Duckworth, was moved down Ocean Avenue several blocks closer to the beach by Frank Devendorf. It became "the nucleus of the present Pine Inn. Tents (renting for a few dollars week) were erected on an adjoining lot, now the site of Lobos Lodge, to take care of the overflow."

Opened at its new location on July 4, 1903, the Pine Inn was the only place in Carmel that served meals throughout the year. Despite low room rates and heavy advertising, business was relatively slow until the 1906 San Francisco earthquake, which brought many scared and homeless refugees to Carmel to escape the chaos. Some stayed only for a few weeks, others became full-time residents. The Arts and Crafts style sun parlor at the inn is pictured below.

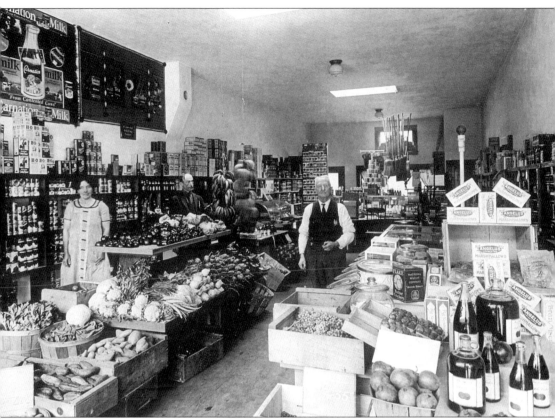

Shown is the orderly interior of Dolores Grocery in 1924. Courtesy of the Henry Meade Williams Local History Department, Harrison Memorial Library, Carmel, CA.

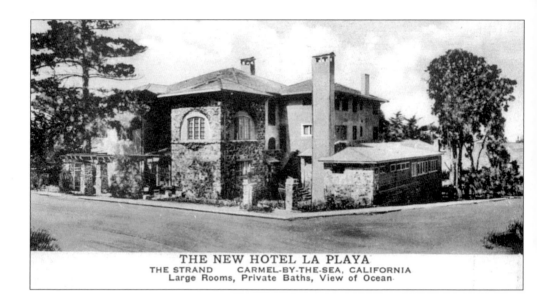

THE NEW HOTEL LA PLAYA
THE STRAND CARMEL-BY-THE-SEA, CALIFORNIA
Large Rooms, Private Baths, View of Ocean

Hotel La Playa on Camino Real was originally the home and studio of painter Chris Jorgensen. After Jorgensen left the area (due to his wife's accidental drowning) it was taken over by Agnes Signor. He turned the property, which included Jorgensen's stone tower, into a hotel in 1921. In 1924 it burned and was rebuilt and enlarged in 1925.

The La Playa Hotel after several additions. "When you arrive at a Carmel hotel," wrote Daisy Botstock and Dorothea Castelhun in 1925, "you won't find a liveried attendant at the door nor a canopy across the sidewalk. Indeed, should things happen to be specially quiet it's just possible that you may have to carry your own luggage into the lobby."

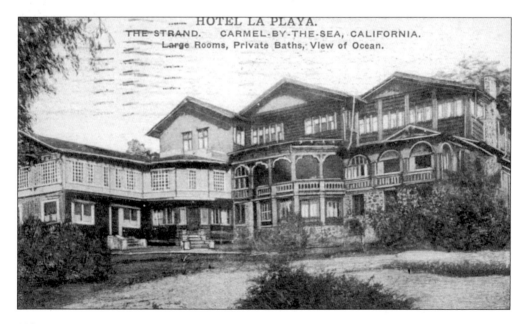

HOTEL LA PLAYA.
THE STRAND. CARMEL-BY-THE-SEA, CALIFORNIA.
Large Rooms, Private Baths, View of Ocean.

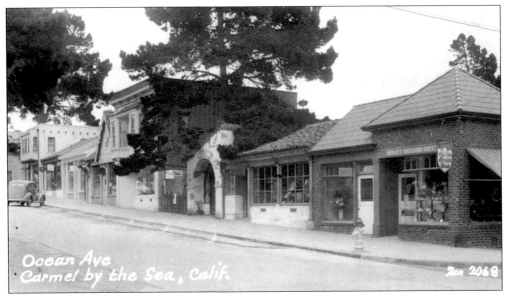

Ocean Ave.
Carmel by the Sea, Calif.

In 1911 Carmel had over 375 houses. Five years later, when it was officially named Carmel-by-the-Sea, there were nearly 600 residents. In 1915 Carmel published its first newspaper, the *Pine Cone*, established by William Overstreet. "If you see it in the *Pine Cone*," the paper boasted, "you may safely repeat it." And, in 1922, after much controversy, Ocean Avenue (seen here) was paved.

In the 1920s, when artists still comprised the majority of the population in Carmel but were alarmed at the notion of progress, they mounted a campaign and "elected an art ticket to the local Board of Trustees. The slogan was 'Keep Carmel off the map. We don't want Boosters' Clubs, get-togethers, organizations of Chambers of Commerce.'" Perry Newberry, author and publisher of the *Pine Cone*, was among the most vocal opponents of progress.

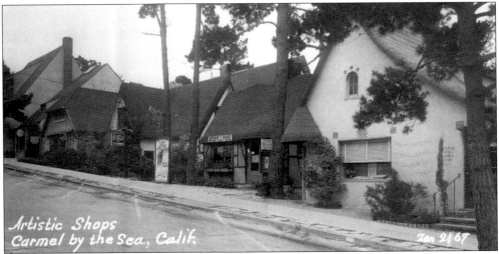

Artistic Shops
Carmel by the Sea, Calif.

In 1929 many residents of Carmel considered erecting a wall around the city to limit entry and protect it from becoming a tourist attraction. The wall never went up but law was drafted to limit the much-feared growth: "The city of Carmel-by-the-Sea is hereby determined to be primarily essentially and predominately a residential city wherein business and commerce have in the past, are now, and proposed to be in future, subordinated to its residential character . . ."

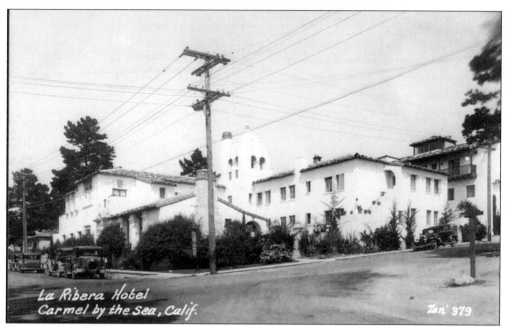

Hotel La Ribera (now the Cypress Inn), built in 1929, is located at Lincoln and 7th and is distinguished for its Moorish-inspired tower and Spanish influences.

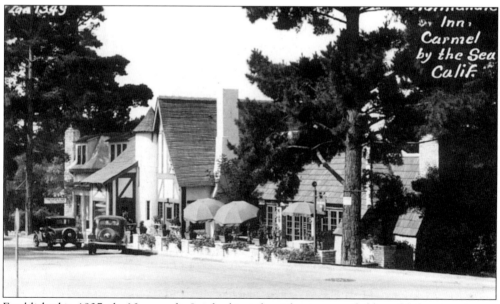

Established in 1937, the Normandie Inn had just the right amount of old-world charm and new-world conveniences to make it acceptable to Carmel's progress-resistant residents. Built around a central courtyard, its Shingle Style, low-slopping roofline and French Provincial-style timber façade was the work of architect Robert Stanton.

The studio of Hugh Comstock, located at Santa Fe and Sixth Street, was built c. 1926. Courtesy of the Henry Meade Williams Local History Department, Harrison Memorial Library, Carmel, CA.

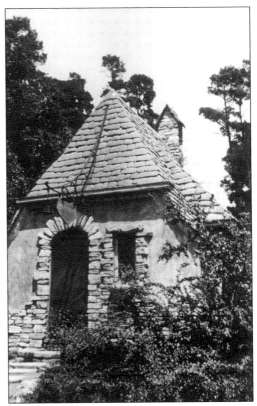

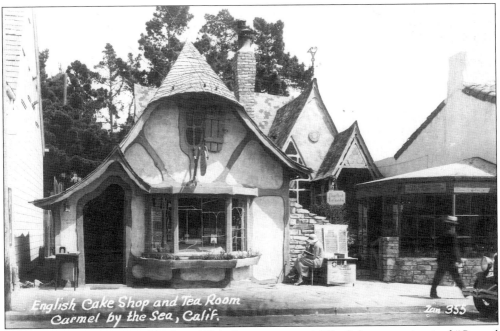

English Cake Shop and Tea Room
Carmel by the Sea, Calif.

Known as the Tuck Box and built in 1926, this quintessential English cottage-inspired "Carmel cottage," is a landmark and perhaps the most well-known example of the work of legendary architect and builder Hugh Comstock.

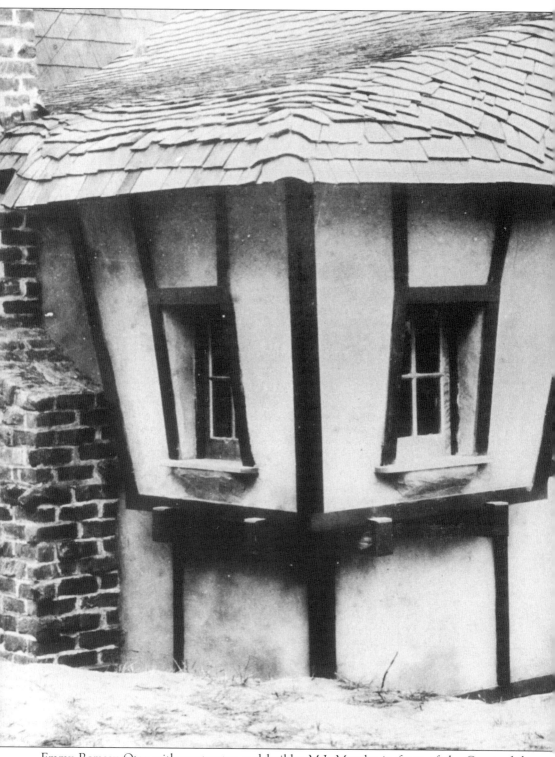

Emmy Ramsey Otey with contractor and builder M.J. Murphy in front of the Court of the Golden Bough, examining plans for the Christian Science Reading Room at Ocean Avenue

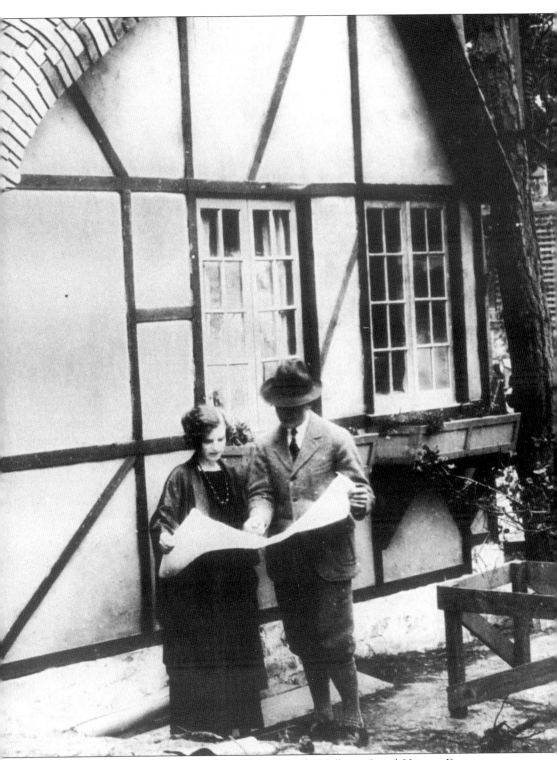

and Monte Verde Street. Courtesy of the Henry Meade Williams Local History Department, Harrison Memorial Library, Carmel, CA.

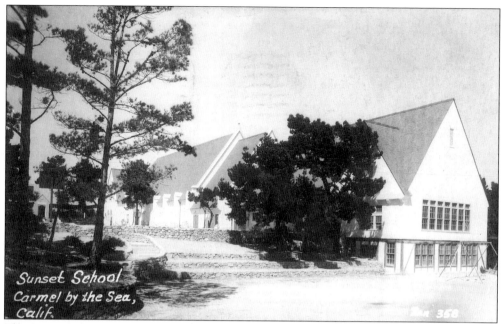

The Sunset School, built in 1925–26 and designed by C.J. Ryland in the Arts and Crafts style, has a steep pitched roof and lancet windows.

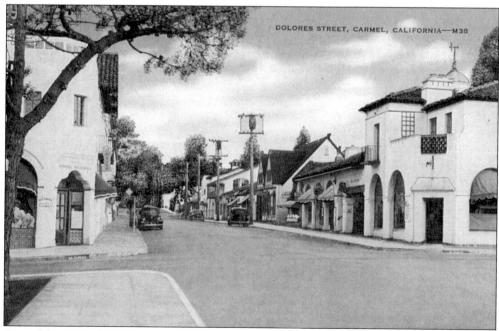

Carmel has an eclectic mix of architectural styles, with many of the principal commercial buildings designed in Spanish Revival, Tudor Revival, and Arts and Crafts styles, but a predominate vernacular Spanish Revival style is the basic underpinnings of the town's charm.

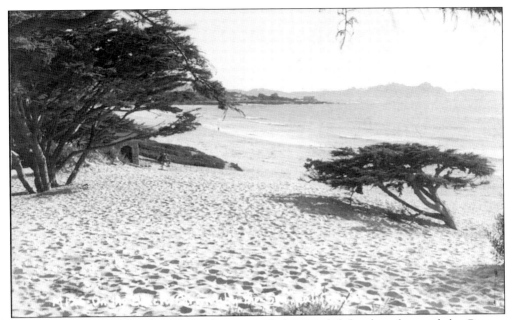

The pure white-sand beach at Carmel is one mile long and defined to the north by Cypress Point and to the south by Carmel Point.

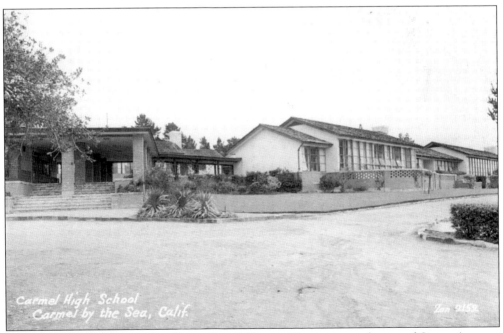

Carmel High School opened in September 1940 on a 22-acre site at the top of Ocean Avenue. Architecturally, it fits within the so-called Bay Area Tradition; William Cranston and Donald Elston were the architects.

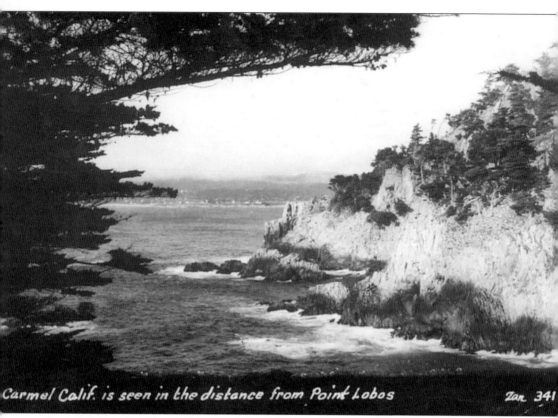

Carmel Calif. is seen in the distance from Point Lobos Zan 341

Point Lobos is the subject of many of the most famous photographs by Edward Weston and the circle of photographers who visited his Carmel Highlands home and studio. At Point Lobos, Weston developed a photographic vocabulary that became a distinct style in modern photography.

Five

POINT LOBOS AND
THE HIGHLANDS

Point Lobos, named *Punta de los Lobos Marion* (point of the seawolves) by Spanish explorers, holds the only natural grove of Monterey Cypress in the world. In 1933 the land was acquired by the state and deemed a reserve, to be "held in trust as nature had designed it."

Frederick Law Olmsted Jr. (1870–1957), son of the famous Massachusetts landscape architect by the same name, and George B. Vaughan were responsible for developing the master plan to return this 450-acre reserve to its natural condition. The massive report read in part, "Again as in the case of great works of art, what people observe at Point Lobos arouses meanings as manifold and as greatly inspiring, or as little, as the knowledge, imagination, and other mental qualities of the individual permit." Olmsted was trained in the naturalistic style of landscaping made popular in America by his father. The junior Olmsted is responsible for the 1929 California State Park System plan. He also served on the board of advisors at Yosemite National Park.

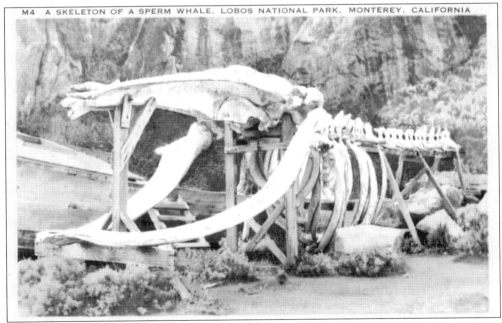

M4 A SKELETON OF A SPERM WHALE, LOBOS NATIONAL PARK, MONTEREY, CALIFORNIA

For almost three decades whaling was a big industry in Monterey starting in 1854 and at Point Lobos in 1862. The small village known as Whalers Cove at Point Lobos, was one of a chain of whaling stations along the California coast. With the introduction of kerosene in the late 1880s and the decrease in demand for whale oil, the industry died.

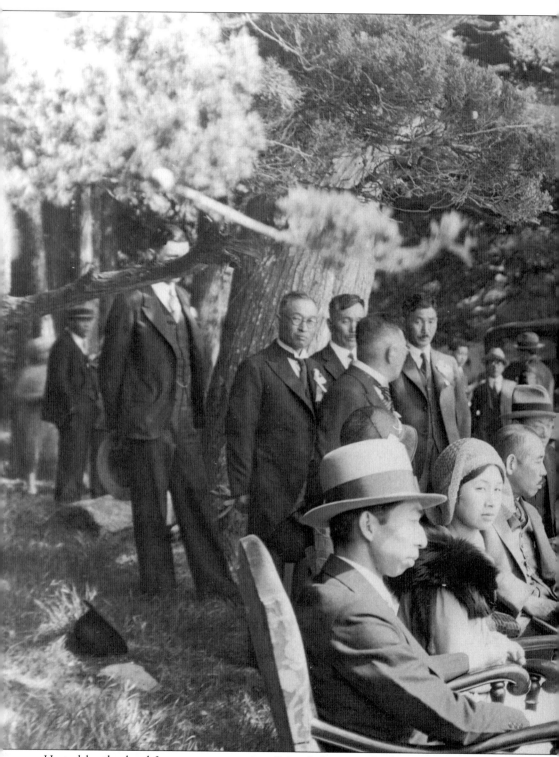

Hosted by the local Japanese community, Point Lobos was the honeymoon destination for Prince and Princess Takamatsu in May 1931. The prince was the brother of Emperor Hirohito.

112

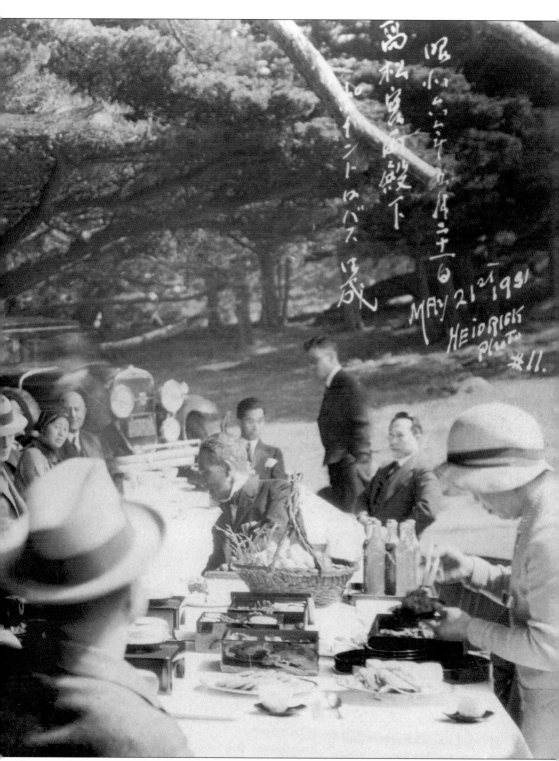

昭和六年五月廿一日
高松宮両殿下

МAY 21st 1931
HEIDRICK
photo
#11.

Photograph by Anton C. Heidrick, courtesy of Monterey Public Library.

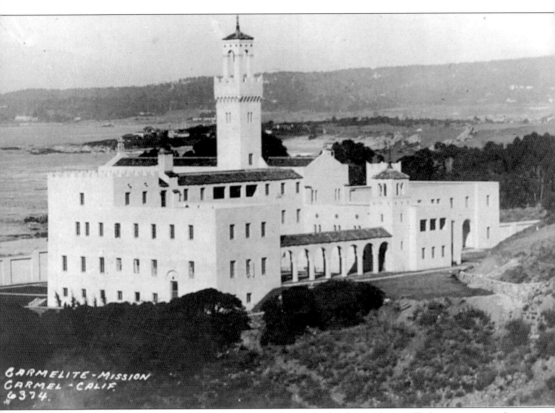

CARMELITE-MISSION
CARMEL-CALIF.
6374.

The spire of the Carmelite Monastery (seen from the back) is about all that most people ever see of this massive structure. Completed in 1931, it is the home of the Carmelite nuns of Our Lady and Saint Therese, a cloistered community which continues to honor a vow of silence. It was designed by Boston architects Charles Maginnis and Paris-trained Timothy Walsh, who designed over a hundred ecclesiastical buildings in the United States.

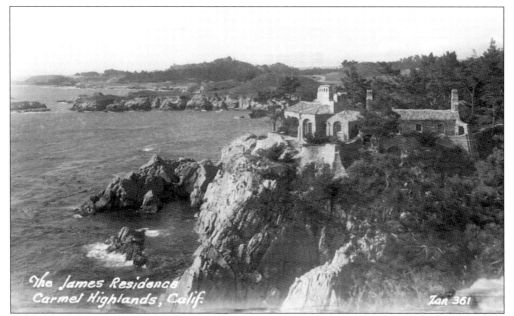

Charles Sumner Greene designed the home of Daniel James, which sits out on a rocky precipice in the Highlands. With his brother, Henry Mather Greene, the pair were famous for the interiors and exteriors of their California Arts and Crafts houses, including those designed for R.R. Blacker in Pasadena (1907), William R. Thorsen in Berkeley (1908), and David Gamble in Arroyo Seco (1909).

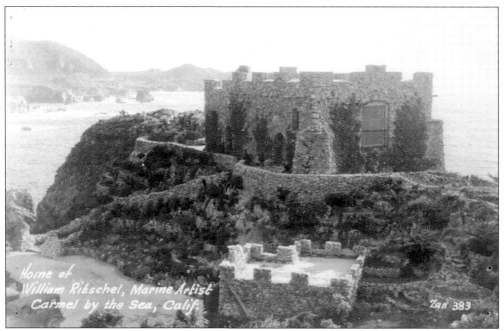

The unforgettable stone castle-like house in the Highlands, designed and built by German-born and trained marine artist William Ritschel, has been a landmark since it was completed.

The area known as the The Highlands was developed by Frank Devendorf, who took special interest in the precise location and design of the original Highlands Inn. When the inn was completed in 1917, it commanded one of the most sweeping and breathtaking views on the peninsula. It was made from locally quarried stone. Photo by Louis Slevin.

The original Old Coast Road, which was a narrow two-lane dirt road, went east around Bixby Creek before the bridge by the same name was built. In wet weather the road was impassable, cutting Big Sur off from the peninsula.

116

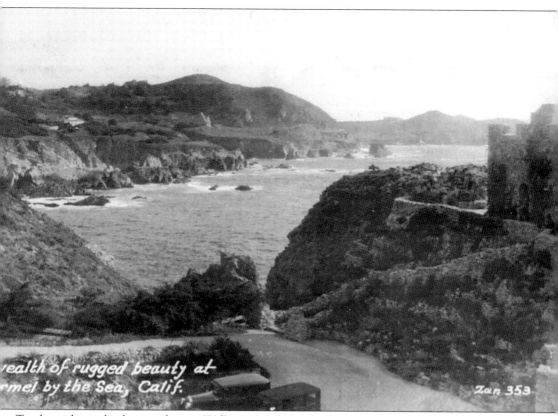

ealth of rugged beauty at
rmel by the Sea, Calif.

Zan 353

To the right is the home of artist William Ritschel, who emigrated in 1895 and arrived in Carmel in 1911. Ritschel continually used the view of the cliffs and shoreline from his house as the subject of his paintings. Starting in 1905 with the establishment of the Del Monte Art Gallery at Hotel Del Monte, the Carmel art scene began to attract national attention. As William H. Gerdts has pointed out, Carmel was the Cape Cod of the west for landscape painters. Starting in 1905 summer classes in painting were offered by the Arts and Crafts Club, with a more intense summer school being organized in the 1910s. Well known artists William Merritt Chase and George Bellows were both guest instructors.

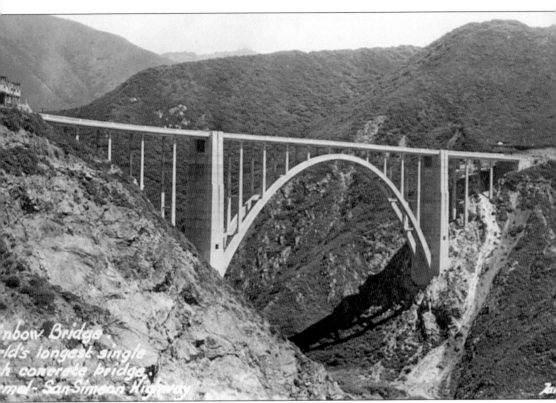

nbow Bridge.
ld's longest single
h concrete bridge.
mel-San Simeon Highway

Dedicated on November 27, 1932, the Art Deco Bixby Creek Bridge (sometimes called Rainbow Bridge), located a little more than 13 miles south of Carmel, was among the world's largest single-arch concrete bridges when it was completed. With a main span of some 320 feet and a length of 714 feet, the bridge was built by Ward Engineering Company of San Francisco.

Six

BIG SUR

The remote coastal community of Big Sur has always been associated with three things: rugged cliffs, redwood forests, and residents who resisted change at any cost. Spanish explorers referred to Big Sur's dramatic vistas as *Ventana* or "the window." Painters, poets, potters, and profits have been drawn to the area for decades and many have made it the subject of their life's work. That Big Sur remained fairly untouched and unsettled until after World War II is due, in part, to the lack of a paved road. The completion of the Pacific Coast Highway in 1937 was considered a national transportation triumph for some, while for others it signaled the death knell of Big Sur as they knew it.

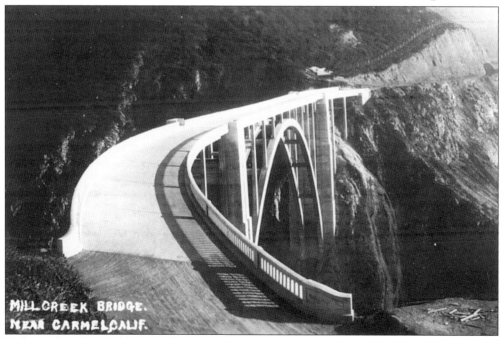

Mill Creek Bridge on the way from Carmel to Big Sur is one of the few curved bridges along the scenic highway.

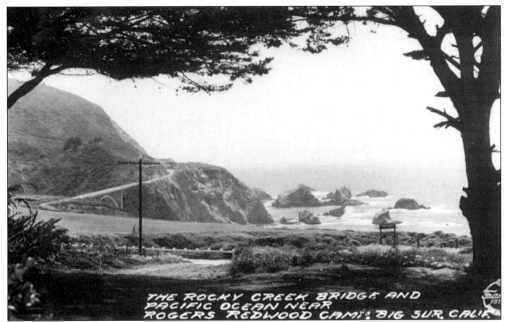

The Rocky Creek Bridge on the way to Big Sur from Carmel can be seen in the distance in this photograph.

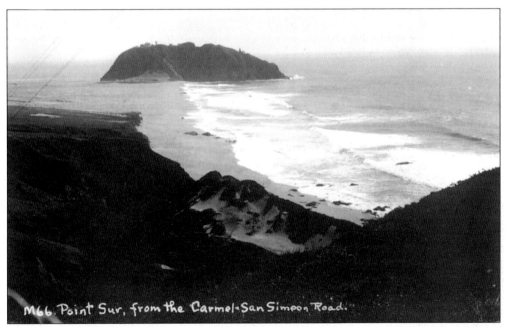

Point Sur Lighthouse Station was completed in 1889. Since then, the point has been the site of several sea disasters, including the wreck of the S.S. *Los Angeles* and the *Ventura*. For many years the families of several lighthouse keepers inhabited the point, which rises 270 feet above the sea. In 1939, management of the lighthouse was taken over by the Coast Guard. It is currently operated by Point Sur State Historic Park, part of the California Department of Parks and Recreation, and is open to the public.

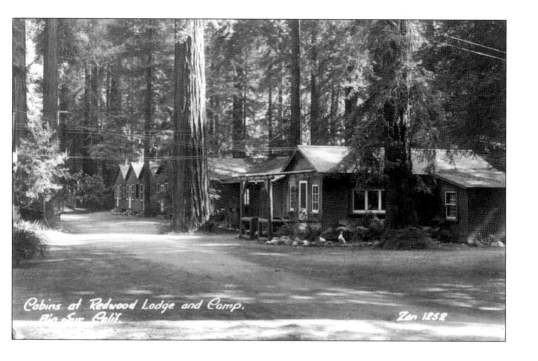

Cabins at Redwood Lodge and Camp. Big Sur Calif.

Zan 1252

With the Santa Lucia Mountains and Los Padres National Forest as its setting, Big Sur has always been a popular hiking and camping destination and is the home of many rustic resorts including Redwood Lodge (*above*) and Ripplewood Resort (*below*).

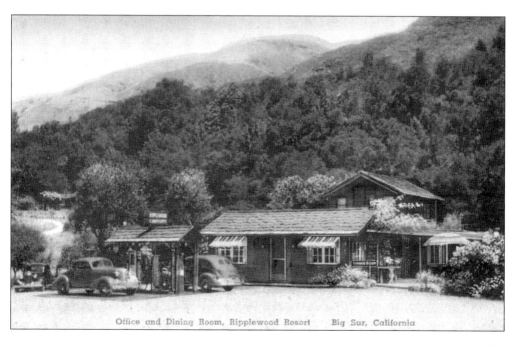

Office and Dining Room, Ripplewood Resort Big Sur, California

The history of Big Sur's River Inn begins in 1888 when Jay Pheneger acquired the land from the federal government. Later, homesteaders Barbara and Michael Pfeiffer, who were farming near Pfeiffer Beach purchased the Pheneger property. In 1934, Ellen Brown, granddaughter of the Pfeiffer's, opened her living room and dining room to the public and built motel rooms nearby, this was said to be Big Sur's first "resort."In 1937, when the Pacific Coast highway was completed, the house moved to the west side of the road and converted to a dining room and kitchen.

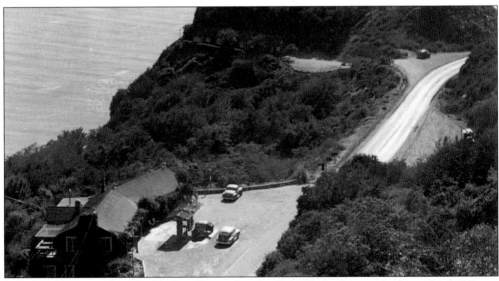

Lucia Lodge, located at the bluff's edge on Pacific Coat Highway, was built in the 1930's on land pioneered and settled by the Harlan family in 1865. The lodge is still operated by members of the Harlan family. According to Augusta Fink, Wilber Harlan homesteaded in Big Sur in 1885. Later he married Ada Danis, daughter of early settlers Gabriel and Elizabeth Dani. In the early 1870s, the Danises and their five children made the trip from Soledad to Big Sur by stagecoach and horseback.

ACKNOWLEDGMENTS

No book is the work of just one person, and I have many others to thank for this one. Among them, Dennis Copeland, archivist at the Monterey Public Library; and Denise Sallee, librarian/archivist at Harrison Memorial Library, both of whom read the manuscript and made valuable observations. I am grateful for the patience and good humor of Keith Ulrich, editor at Arcadia Publishing.

Thanks to my fellow postcard collector, Celia Hilliard, for her steadfast encouragement. To those who read the manuscript in draft form, Rick Janick, Arthur H. Miller, Patty Dowd Schmitz, and Kent Seavey, thank you for your insightful comments, corrections, and contributions. Two lifelong friends, Russell Campbell and his sister, Jeanette Campbell, provided much needed research assistance. Special thanks to my mother Nancy Borucki.

I wish to acknowledge my debt to the many authors who paved the way and upon whose books and articles I have relied for much of my understanding and information. They include, Daisy F. Bostick, Dorothea Castelhun, James Ladd Delkin (editor of the WPA guide to the peninsula), August Fink, Anne Germain, Harold and Ann Gilliam, Sharron Lee Hale, Neal Hotelling, Lucinda Jaconette, Robert B. Johnston, Betty Lewis, Randall A. Reinstedt, Geoff Shackelford, Jeanne Van Nostrand, and John Walton. I have quoted liberally from two small but important early guidebooks, *The Hand Book to Monterey and Vicinity* (1875), and *Historical Monterey and Surroundings* (1899).

BIBLIOGRAPHY

Architecture of the Monterey Peninsula. Monterey, CA: Monterey Peninsula Museum of Art, 1976.

Bostick, Daisy and Castelhun, Dorothea. *Carmel at Work and Play.* Carmel, CA: The Seven Arts, 1925.

Brown, Wallace Clarence. *Historic Monterey and Surroundings Illustrated.* Special Souvenir Edition. 899

"Carmel By The Sea." Carmel Realty Company. Brochure. ND.

Dana, Richard Henry Jr. *Two Years Before the Mast.* New York: The Heritage Press, [originally 1840] 1947.

Delkin, James Ladd. *Monterey Peninsula.* American Guide Series. Work Projects Administration Northern California Writers' Project, 1946.

Drury, Newton B. "Point Lobos Reserve." *American Forests,* July 1938. Washington, D.C.: The American Forestry Association.

Dunn, Arthur. *Monterey County California.* Souvenir of the Panama–Pacific International Exposition. San Francisco, CA: Sunset Magazine Homeseeker's Bureau for the Board of Supervisors of Monterey County, 1915.

Fink, Augusta. *Monterey County: The Dramatic Story of Its Past.* Fresno: Valley Publishers, 1978.

Gerdts, William H. *Art Across America: Two Centuries of Regional Painting.* New York, NY: Abbeville Press, Vol III, 1990.

Germain, Anne. *Pebble Beach: The Way It Was.* Privately Published, 1946.

Golf and the Other Sports at Del Monte. San Francisco: Press of H.S. Crocker. c. 1895.

Hale, Sharron Lee. *A Tribute to Yesterday: The History of Carmel, Carmel Valley, Big Sur, Point Lobos, Carmelite Monastery, and Los Burros.* Santa Cruz, CA: Valley Publishers Western Tanager Press, 1980.
Hand Book to Monterey and Vicinity. Walton & Curtis, 1875.

Horne, Kibbey, M. *A History of the Presidio of Monterey 1770 to 1970.* Monterey, CA:

Defense Language Institute West Coast Brach, 1970.

Hotelling, Neal. *Pebble Beach Golf Links: The Official History.* Chelsea, MI; Sleeping Bear Press, 1999.

Jaconette, Lucinda. *Monterey Bay: The Ultimate Guide.* San Francisco, CA: Chronicle Books, 1999.

Johnston, Robert B. *Old Monterey: A Pictorial History.* Monterey, CA: Monterey Savings and Loan Association, 1970.

Lewis, Betty. *W.H. Weeks: Architect.* Fresno, CA: Panorama West Books, 1985.

Lussier, Toni Kay. *Big Sure—A Complete History and Guide.* Big Sur, CA: Toni K. Lussier and Big Sur Publications, 1979.

May, Cliff. *Sunset Western Ranch Houses.* Sunset Series. San Francisco, CA: Lane Publishing Company, 1946.

McGlynn, Betty Hoag. "Casa De Las Olas." *Noticais del Puerto de Monterey*, Vol. XXVI, No. 2, June 1985. Monterey, CA: The Monterey History and Art Association.

Mizner, Addison. "A Mecca For Artists: Where Land and Water Blend in Beauty." *California Arts & Architecture*, January, 1932.

Monterey's Adobe Heritage. Monterey, CA: Monterey Savings and Loan Association, 1965.

Reinstedt, Randall A. *Where Have All the Sardines Gone?* 1978.

Reese, Robert W. *A Brief History of Old Monterey.* Monterey, CA; Monterey City Planning Commission, 1969.

Shackelford, Geoff. *Alister MacKenzie's Cypress Point Club.* Chelsea, MI: Sleeping Bear Press, 2000.

Shepard, A.D. *Pebble Beach, Monterey County California.* Booklet. San Francisco, CA: Press of H.S. Crocker Company, 1909.

Van Nostrand, Jeanne. *A Pictorial and Narrative History of Monterey Adobe Capital of California 1770–1847.* San Francisco, CA: California Historical Society, 1968.

Walton, John. *Storied Land: Community and Memory in Monterey.* University of California Press, 2001.

Woodbridge, Sally B. *California Architecture: Historic American Buildings Survey.* San Francisco, CA: Chronicle Books, 1988.

Index

Illustration Credits

Illustration credits for images in the collection of the author.

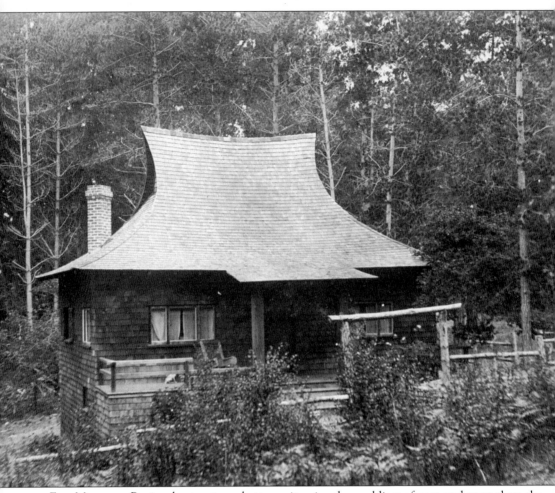

Few Monterey Peninsula structures better epitomize the melding of east and west than the studio of Isabel Chandler, seen here in c. 1910. This creative eclectic fusion of Anglo-American Shingle Style in its natural setting, with south Asian bungalow and East Asian tea house elements and materials, is reflective of the creative fervor in Carmel.